Lettering

WORKSHOP FOR *Crafters*

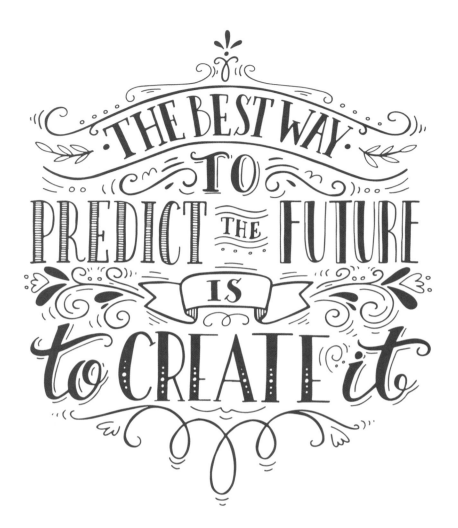

THE BEST WAY TO PREDICT THE FUTURE IS to CREATE it

ISBN 978-1-4972-0405-8

© 2018 by Suzanne McNeill and New Design Originals Corporation, *www.d-originals.com*, an imprint of Fox Chapel Publishing, 800-457-9112, 903 Square Street, Mount Joy, PA 17552.

Lettering Workshop for Crafters is a collection of new and previously published material. Portions of this book have been reproduced from *Letter Better* (ISBN: 978-1-57421-741-4), *Lettering 101 for Scrapbooks & Cards* (ISBN: 978-1-57421-812-1), and *Oodles of Doodles, 2nd Edition* (ISBN: 978-1-4972-0413-3).

Photos from Shutterstock.com: Julia Henze (2); Ksw Photographer (textured background behind headers on pages 4–8, 18–20, 22, 24, 136–143, 158, and 160, textured paper on pages 10–11 and 13–15); Shtonado ("Vintage" 5, alphabet 106–107); ddok (stationary supplies 6–7); LUCKY_CAT (heart 7); Reinekke (rose tattoo 7); Jakub Krechowicz (black and white alphabet 7); In Green (hieroglyphics tablet 7); shinshila (top left 8); Veronika Telyatnikova (bottom left 8); kondratya (top right 8); Mr Doomits (bottom right 8); Evikka (bottom left 10); katrinrich (bottom right 14); Duong Hoang Dinh ("Vibes" and "Plans" 16); Viktoria Raikina ("Meditate" 16); Vitalino11 ("Good morning" 16); Anastasiia Gevko ("Dinner menu" 16); Akvals (tea and paper background 16); MINI_Panda (bottom left 17); Sergey Skleznev (bottom right 17); Africa Studio (bottom left 18); Lainea (top right 18); Akkalak (bottom right 18); xpixel (bottom left 20); Julia Henze (21); Rawpixel.com (top 22); I Love Coffee dot Today (middle 22); Jiri Vondrous (bottom 22–23); dfrolovXIII (23); VanoVasaio (bottom left 24); Bibadash (25); GUGAI (alphabet 42–43); ledokolua (alphabet 116–117); zao4nik (alphabet 132–133); ugina (alphabet 134–135); Yurlick ("Be Creative" 142); Fabien Monteil (alphabet background 142–143); lesyaskripak (all images 158); LarinaTatyana (alphabet background 159); Vectorcarrot ("I Can and I Will" 160); and Tirachard Kumtanom (pencils 160 and back cover).

We are always looking for talented authors. To submit an idea, please send a brief inquiry to acquisitions@foxchapelpublishing.com.

Printed in Singapore
First printing

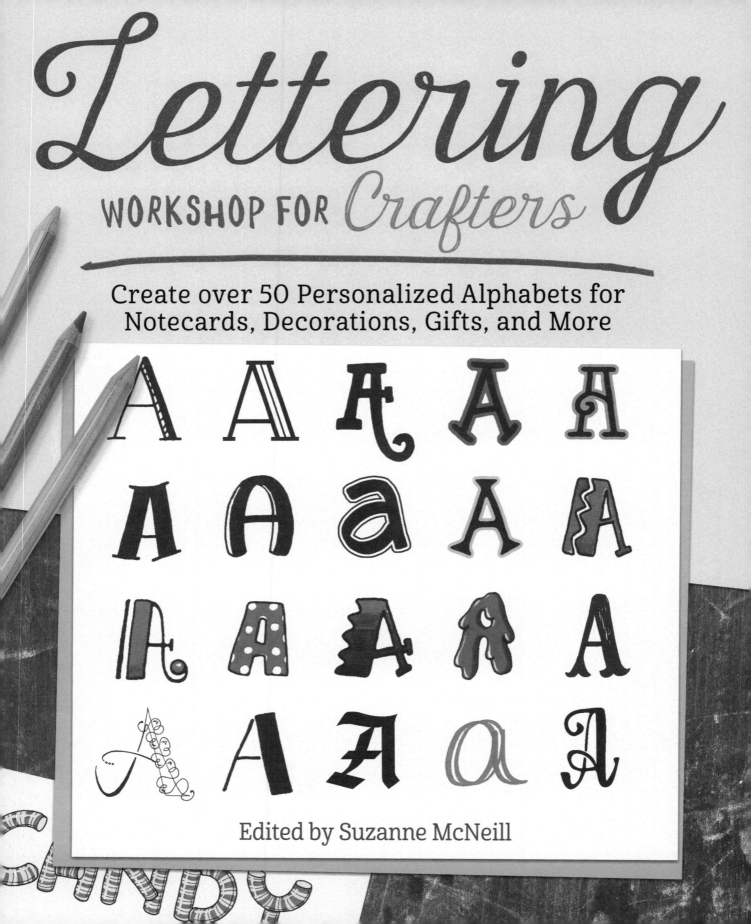

Lettering

WORKSHOP FOR *Crafters*

Create over 50 Personalized Alphabets for Notecards, Decorations, Gifts, and More

Edited by Suzanne McNeill

Lettering WORKS

Workshop Syllabus

SHOP FOR *Crafters*

AAAA **ABCDEFGHIJKLMN**

VINTAGE BOOK CLUB

Welcome TO Letterin[g]

Lettering can be fun and easy, but it can also really make your work stand out. This book shows you how to create a ton of effects from shadows to zigzags, swirls to stitches, and curves to slants. Each of these lettering effects will add color, interest, and pizazz to your projects!

Whether you're painting a sign, putting up a bulletin board, designing an appealing page in your journal, sending an invitation, or doing a craft project, this book will have an alphabet for you. Use these pages to learn and practice it. In a world where everything is a computerized font, your handwritten touch will mean so much more.

As you practice, you may find that you're gradually creating your own signature lettering style. That's great! You can let it develop naturally, or you can use the blank alphabet pages starting on page 136 to work on it.

This book SHOWS YOU HOW TO *create a ton of effects* FROM SHADOWS TO ZIGZAGS, *swirls to* stitches, AND *curves to slants.*

Beautiful lettering is a timeless practice.

Beautiful lettering is a timeless practice. You can see it in Egyptian hieroglyphics, illuminated manuscripts from the Middle Ages, twenty-first-century tattoos, and art exhibits everywhere. And now you can see it on your own projects!

Remember to match your colors to the theme of the design. You will be amazed at the unique and fun patterns you can create.

Suggested Supplies

Part of the fun of lettering is finding the right pens and markers to use. You can use pens as small as .005mm for tiny, tiny lines and dots. Calligraphy pens make lines from fine to bold. To add color to your lettering, there are rainbow collections of watercolor markers.

Use this book at a table or desk where you can sit comfortably with your feet on the floor. It should have good lighting and enough space to keep your pens close at hand. Each of the alphabets in this book will suggest a type of pen to start with, but feel free to experiment with mixing and matching.

And of course, if you're thinking of transferring your letters to something larger, you'll need to vary your tools. Your delicate calligraphy pen won't write well on a wooden sign. Practice on paper first, and when you're ready, switch to chalk, paint, or your medium of choice.

STORAGE

Markers and pens last longer when they are stored horizontally rather than standing up. Lay markers and pens in a drawer, plastic tub, or box for periods when they are not in use. It also helps to store pens in an airtight container.

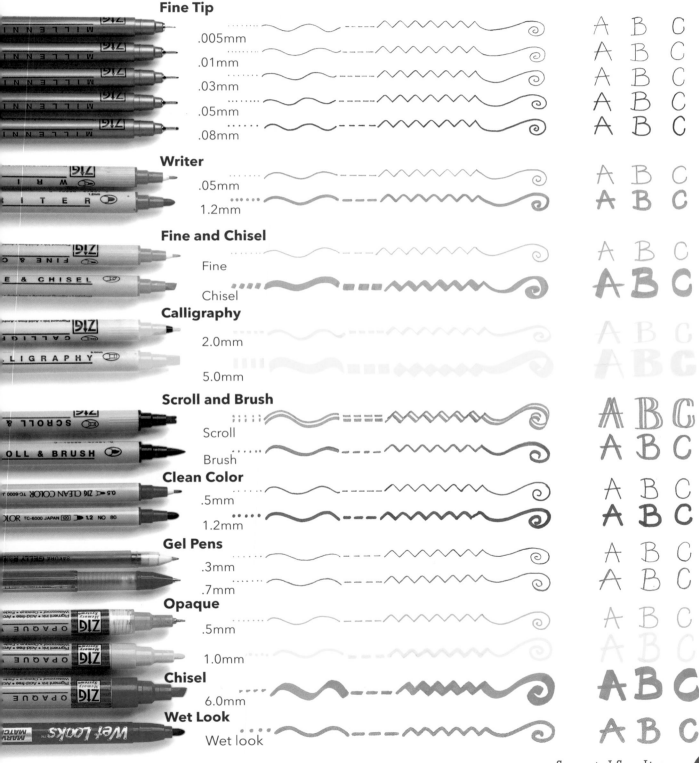

Fine Tip
- .005mm
- .01mm
- .03mm
- .05mm
- .08mm

Writer
- .05mm
- 1.2mm

Fine and Chisel
- Fine
- Chisel

Calligraphy
- 2.0mm
- 5.0mm

Scroll and Brush
- Scroll
- Brush

Clean Color
- .5mm
- 1.2mm

Gel Pens
- .3mm
- .7mm

Opaque
- .5mm
- 1.0mm

Chisel
- 6.0mm

Wet Look
- Wet look

Fine Tips

~words~ ~words~ ~words~ ~words~ ~words~

The .005mm pen tip is great for hash marks, highlights, stitches, and tiny wording. Be gentle when writing, since this tip is very delicate and breaks or bends easily.

Use the .01mm tip for outlining and fine detailing inside block letters.

The .03mm tip is just right for the zigzag or appliqué style.

The .05mm tip is great for writing letters and adding dots. It is also thick enough to use for outlines.

BOLD · · · BOLD · · · BOLD · · · ·

When you want to make a bold statement, use the .08mm tip. It is just the right thickness for block letters, borders, and outlining.

TIPS AND TECHNIQUES

1. Before starting a project, wash and dry your hands to prevent smudging or soiling your paper.

2. Rest your hand on the work surface for balance and hold the pen at a right angle to the paper.

3. Press lightly and move smoothly. Avoid holding the pen in one place too long to prevent bleeding or unwanted dots.

4. Use a ruler and pencil to lightly draw guidelines to keep letters straight, then erase with a white eraser. Make sure you wait a few minutes for the ink to totally dry.

Use a pencil to draw letter.

Add Triangle when outlining.

Erase pencil lines.

TRIANGULAR COLOR

A B C D E F
G H I J K L
M N O P Q R
S T U V W X
Y Z 1 2 3 4 5 6 7 8 9 0

~.03 fine tip~

Gel Pens

TIPS AND TECHNIQUES

1. Hold your gel pen just like a regular pen. The gel pen's ink rolls on smoothly, so there is no need to press hard.

2. Gel pen ink takes a little longer to dry, so wait a few minutes before erasing any pencil lines to avoid smudges.

3. Gel colors are opaque and work well on colored papers as well as white paper. Try using gold and silver to highlight lettering on black paper.

Writer Pens

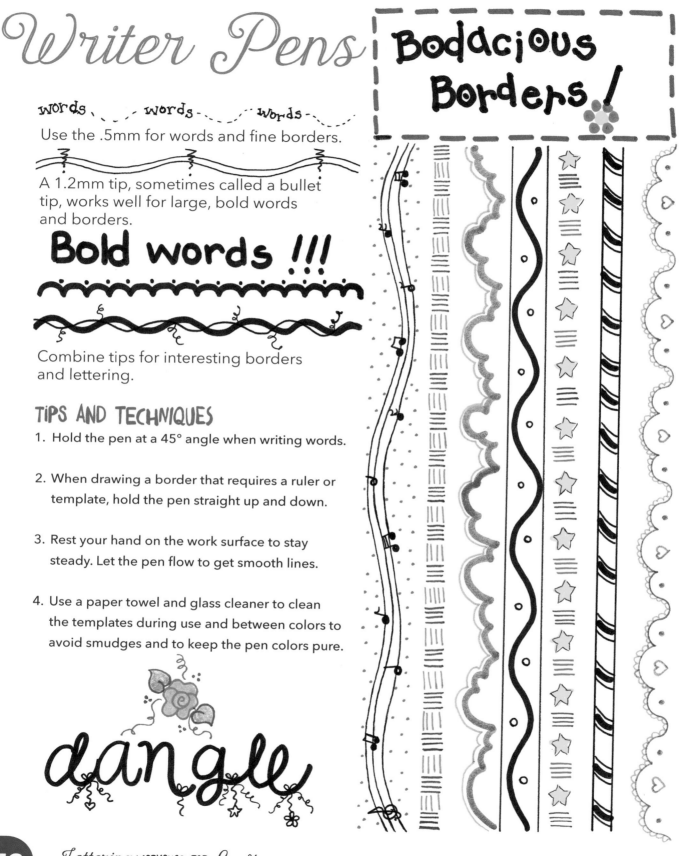

Bodacious Borders!

words — words — words

Use the .5mm for words and fine borders.

A 1.2mm tip, sometimes called a bullet tip, works well for large, bold words and borders.

Bold words !!!

Combine tips for interesting borders and lettering.

TIPS AND TECHNIQUES

1. Hold the pen at a 45° angle when writing words.

2. When drawing a border that requires a ruler or template, hold the pen straight up and down.

3. Rest your hand on the work surface to stay steady. Let the pen flow to get smooth lines.

4. Use a paper towel and glass cleaner to clean the templates during use and between colors to avoid smudges and to keep the pen colors pure.

dangle

Chisel Tips

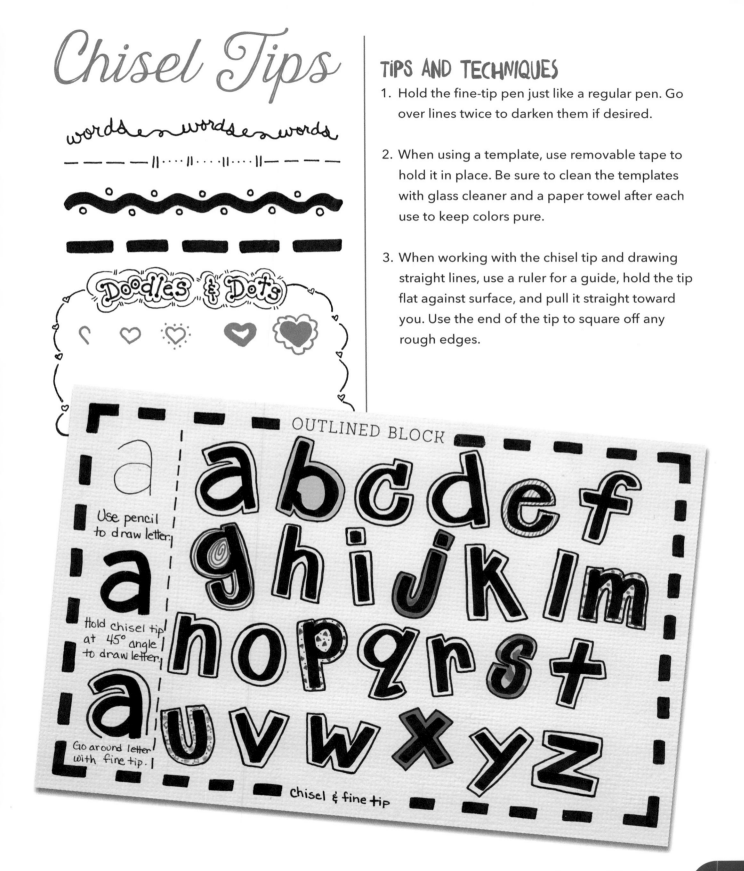

TIPS AND TECHNIQUES

1. Hold the fine-tip pen just like a regular pen. Go over lines twice to darken them if desired.

2. When using a template, use removable tape to hold it in place. Be sure to clean the templates with glass cleaner and a paper towel after each use to keep colors pure.

3. When working with the chisel tip and drawing straight lines, use a ruler for a guide, hold the tip flat against surface, and pull it straight toward you. Use the end of the tip to square off any rough edges.

wordsenwordsenwords

Doodles & Dots

OUTLINED BLOCK

Use pencil to draw letter.

Hold chisel tip at 45° angle to draw letter.

Go around letter with fine tip.

a b c d e f g h i j k l m n o p q r s t u v w x y z

chisel & fine tip

Calligraphy Pens

TIPS AND TECHNIQUES

1. Always hold the calligraphy pen tip flat against the paper. Never write with the corner of the tip.

2. Practice by making curves and loops. Keep your hand and arm relaxed.

3. For classic calligraphy, you'll want to keep the slant of all your lines the same. Place the pen at a 45° angle up from horizontal and practice drawing lines and curves. Holding the pen at a consistent angle will give you the thick and thin strokes that are characteristic of calligraphy.

4. Try some 90° lines, too. Work on being consistent, staying loose, and building a rhythm as you write.

Scroll Tip

TIPS AND TECHNIQUES

1. Hold the scroll-tip pen just like a regular pen. Go over lines twice to darken them if desired.

2. When using a template, use removable tape to hold it in place. Be sure to clean the templates with glass cleaner and a paper towel after each use to keep colors pure.

3. When working with the chisel tip and drawing straight lines, use a ruler for a guide, hold the tip flat against surface, and pull it straight toward you. Use the end of the tip to square off any rough edges.

Use a ruler for a straight-line border.

Make two wavy lines and add short lines with a fine-tip pen for a rope effect around the script alphabet.

Tape a template in place with removable tape to create this easy scallop.

Follow these easy steps to create a box border. Use a ruler to keep the lines straight. Add letters inside each box if desired.

DOUBLE SCRIPT

a b c d e f g
h i j k l m n
o p q r s t u
v w x y z &
1 2 3 4 5 6 7 8 9 0

Draw letter with pencil. Hold tip flat against paper.

Be sure to press down against paper to prevent skipping.

Scroll Tip

Suggested Supplies

15

Brush Tips

The harder you press, the thicker your line will be. Somewhere in between works best. It is easier to control and your words will look smoother.

TIPS AND TECHNIQUES

1. The brush tip is easy to use. However, if you want dimension in your doodling, you will need to practice.

2. Practice writing letters using different pressures at different points. The harder you push, the thicker your letters or lines will be.

3. Because the end of the tip is finely pointed, you need to be gentle or you will wear the tip out and get a rough edge.

Light touch

Vibes

plans

Meditate

Heavy touch

Good morning

Dinner Menu

Markers & Colored Pencils

One way to make your lettering extra fun is to add some color. The examples in this book were created with a combination of permanent markers and colored pencils.

TIPS AND TECHNIQUES

1. Create the shape of the letter you want using permanent marker.

2. Use colored pencil to fill it in with shading, gradation, or bright colors.

Other options for adding color to your letters:

• Markers are great for clean, bright colors. If done in permanent ink, they will last for a very long time without fading.

• Opaque watercolor markers give a vibrant, hand-painted look.

• Use artist chalks applied with a sponge or cotton applicator for a soft, old-fashioned look.

• Try cutting your letters directly from colored cardstock for a bright, sharp design.

MARKER
PAINT
CHALK
PENCIL

COLORS MAKE LETTERING FUN

Space It Out

Pencil sketches are your friends! Take some time to plan how your layout will work, and put your pencil and eraser to good use. Here are some tips for making it work:

- **Use margins.** If you're going to letter more than a short phrase, you'll need to take margins—top, bottom, and sides—into account when planning where your words will go.

- **Build a clear hierarchy of information.** Make it easy for your readers; use size, color, and spacing to emphasize the most important thing they need to read. Make it clear where their eye should go next.

- **Line up the lines.** If you're working on paper, you could slip a lined page underneath your sheet (tape it down!) or use a ruler to draw light pencil lines on top of it. If you're working on something larger—a mirror, chalkboard, mason jar, etc.— removable tape is handy for this.

- **Space consistently.** Keep letters the same size and spaced evenly throughout your piece. Try not to letter some sections smaller and tighter than others; this will make them appear darker on the page.

- **Having trouble centering something?** Start in the middle. Line up the middle letter where you want it to go, and then add letters to the left and right.

Parts of a Letter

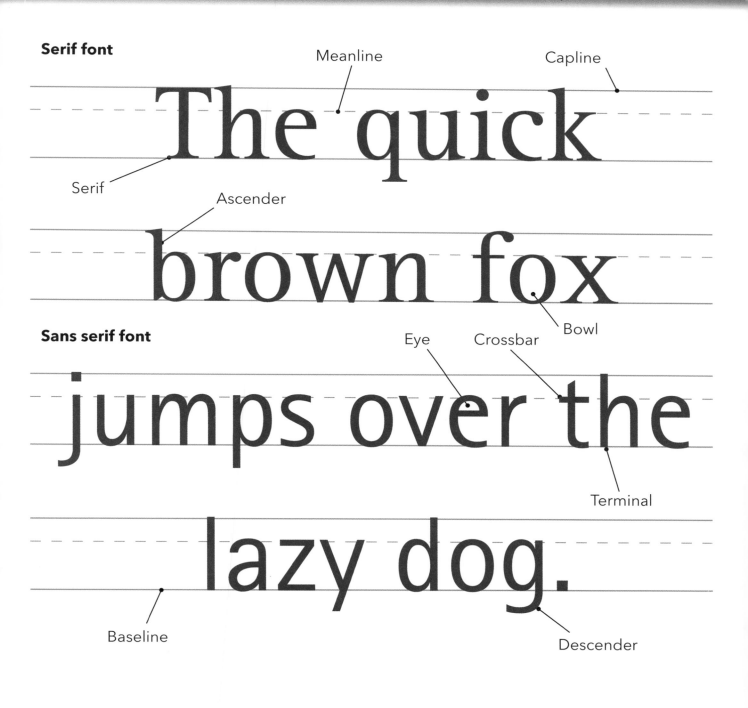

Serif font

Meanline

Capline

The quick

Serif

Ascender

brown fox

Bowl

Sans serif font

Eye

Crossbar

jumps over the

Terminal

lazy dog.

Baseline

Descender

Design Tips

- When choosing which alphabet to use, think about who will be reading it and in what context. If you want something beautiful that someone will spend a minute admiring, go for that complicated script. If you need someone to read it in one second as they walk past it, choose something simple and easy to read.

- Think about the mood that your alphabet conveys, too. Is it calm and flowing? Is it spiky and exciting?

- Remember learning about the color wheel? This is an opportunity to apply it to your work. Choose the right colors to convey the mood you want, and remember that complementary colors will draw attention.

- Think about where your project will be displayed. Do you need it to blend in with, complement, or stand out against its surroundings? Choose your alphabet accordingly.

Lettering WORKSHOP FOR *Crafters*

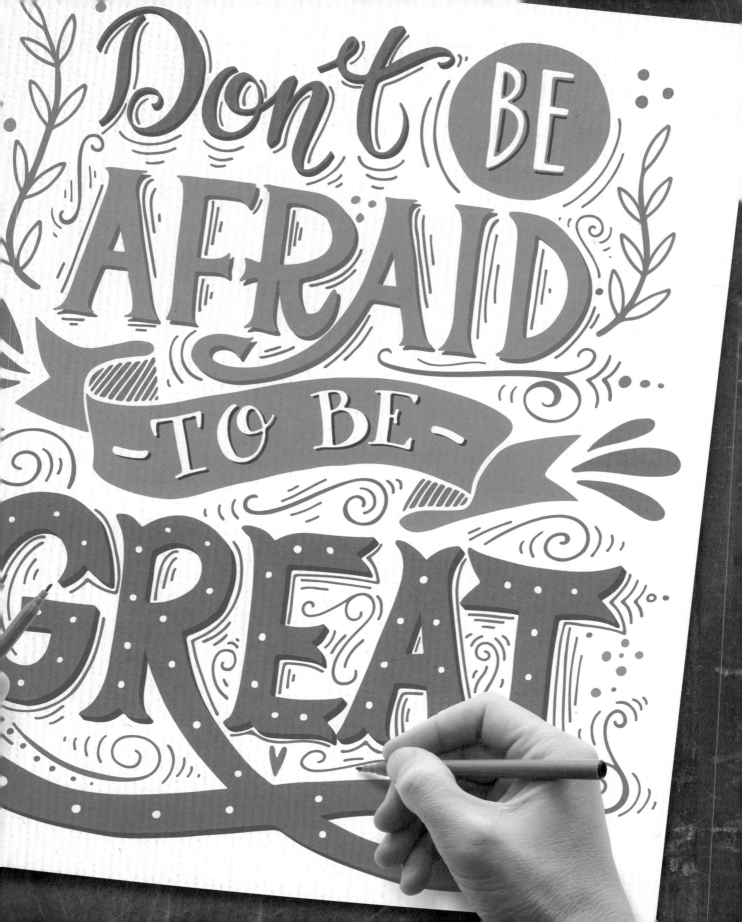

What Are You Writing On?

When you're working with paper, simply choose a paper stock that suits your purpose. Test your writing utensil first to make sure it doesn't bleed through to the other side. But what if you're thinking outside the sketchbook? Here are some tips for lettering on other materials.

- **Wood:** Try paint markers or craft acrylic paint. Prep the wood first by cleaning, sanding it well, and applying an even wood stain or clear primer if necessary. When you're finished lettering, cover it with clear varnish.

- **Glass or glazed ceramics:** Use acrylic enamel paint. If it's clear glass, you can tape your template or lines to the other side for reference. Look for paint markers or window markers, too; test to see how permanent your choice is before using it.

- **Chalkboard:** There's chalk, of course, but there are also chalk markers that make bright, easily controlled colors.

- **Fabric:** Fabric markers or fabric paint can get you what you want, and washable fabric pencils will help you line it up. Wash your fabric first, and read the manufacturer's instructions carefully for post-lettering care. For a classic 3D look, there's always puffy paint! To really take it to the next level, sketch your letters in washable fabric pencil and embroider over them.

The Alphabets

The alphabets that follow vary in style, so you'll never run out of lettering ideas for your projects. Each alphabet comes with directions, suggested tools, and enough practice space for you to write directly on the page. There is also space at the end to use when you're inspired to create your own lettered alphabets. Let the learning begin!

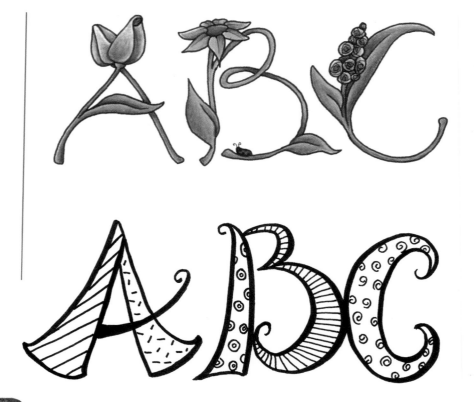

Round Letters

a

How to Do This Alphabet

1. Make your letters big and broad, keeping your hand in motion.
2. Curl the ends in.

a a a b b

c c d d

e e f f

g g h h

i i j j

k k l l

m m ___ n n ___

o o ___ p p ___

q q ___ r r ___

s s ___ t t ___

u u ___ v v ___

w w ___ x x ___

y y ___ z z ___

it's a girl!

The Alphabets

27

Slanted Letters

How to Do This Alphabet

1. Use a pencil and ruler to draw a light slanted line, to represent your baseline.

2. Draw the letter on the line, making sure all crossbars are parallel to the baseline. Erase all pencil lines.

Suggested Tools:

- 1.2mm writer pen
- Ruler

Lettering WORKSHOP FOR *Crafters*

M M _____ N N _____

O O _____ P P _____

Q Q _____ R R _____

S S _____ T T _____

U U _____ V V _____

W W _____ X X _____

Y Y _____ Z Z _____

MAKE A WISH

Fancy Letters

How to Do This Alphabet

1. Draw a basic letter in pencil.

2. Add swirls and curves to appropriate parts of the letter, and soften all points into gentle curves.

3. Outline the letter in ink and erase all pencil lines when the ink is dry. Go over the outside of the letters with a colored marker.

Suggested Tools:
- Any pen
- Colored marker

Lettering WORKSHOP FOR *Crafters*

N *n* _____ N *n* _____

O *o* _____ P *p* _____

Q *q* _____ R *r* _____

S *s* _____ T *t* _____

U *u* _____ V *v* _____

W *w* _____ X *x* _____

Y *y* _____ Z *z* _____

COSTUME PARTY

Serif Letters

How to Do This Alphabet

1. Draw a basic letter in pencil.

2. Add a serif to the tips of the letters. Draw them horizontally or at angles.

3. Outline the letter in ink and erase all pencil lines when the ink is dry. Go over the outside of the letters with a colored marker. Alternatively, start with a colored marker, then outline it in black.

Suggested Tools:

- Any pen
- Colored marker

Lettering WORKSHOP FOR *Crafters*

M M ___

O O ___

Q Q ___

S S ___

U U ___

W W ___

Y Y ___

N N ___

P P ___

R R ___

T T ___

V V ___

X X ___

Z Z ___

COFFEE TIME!

Triangular Letters

How to Do This Alphabet

1. Draw a basic letter in pencil.

2. Draw triangles on the tips of the letters, then soften the angles where the triangles meet the letter lines. Soften places where the letter lines meet each other.

3. Outline in ink, let dry, and erase the pencil lines. Go over the outside of the letters with a colored marker.

A A A

B B

C C

D D

E E

F F

G G

H H

I I

J J

K K

L L

M M ____ ____ N N ____ ____

O O ____ ____ P P ____ ____

Q Q ____ ____ R R ____ ____

S S ____ ____ T T ____ ____

U U ____ ____ V V ____ ____

W W ____ ____ X X ____ ____

Y Y ____ ____ Z Z ____ ____

WASH and DRY

Swirly Letters

How to Do This Alphabet

1. With a pencil, draw a serif letter, keeping all serifs horizontal.

2. Add a swirl to the letter and overlap a swirl on top of the line it touches.

3. Outline the letter in ink without drawing a line through the swirl. Erase all pencil lines then go over the outside of the letters with a colored marker.

Suggested Tools:
- Any pen
- Colored marker

Lettering WORKSHOP FOR Crafters

M M N N

O O P P

Q Q R R

S S T T

U U V V

W W X X

Y Y Z Z

TEA PARTY

Fancy Swirly Letters

How to Do This Alphabet

1. Draw a swirly letter in pencil. Instead of using line serifs, make each serif a single curve.

2. Widen the lines, alternating between thick and thin.

3. Outline the letter in ink and fill in any open spaces. Erase the pencil lines then go over the outside of the letters with a colored marker.

Suggested Tools:

- Any pen
- Colored marker

Lettering WORKSHOP FOR *Crafters*

M M _____ N N _____

O O _____ P P _____

Q Q _____ R R _____

S S _____ T T _____

U U _____ V V _____

W W _____ X X _____

Y Y _____ Z Z _____

DRAGONFLY

Roman-Style Letters

How to Do This Alphabet

1. Use the 1.2mm writer pen to create a thick line.

2. Add thin lines with a .5mm tip.

3. Cross at the bottom and add dashes inside, or leave it open and add color.

Suggested Tools:

- 1.2mm writer pen

- .5mm writer pen

Lettering WORKSHOP FOR Crafters

M M N N
O O P P
Q Q R R
S S T T
U U V V
W W X X
Y Y Z Z

THJ

1 2 3 4 5
6 7 8 9 0

Art Deco Letters

How to Do This Alphabet

1. Draw a basic letter with a pencil and ruler.

2. Add lines to one or two areas of the letter to give it a block-letter look. Add serifs.

3. With a 1.2mm writer pen, outline the letter then erase the pencil lines. Using a .5mm writer pen, create a straight line down the middle of the thicker areas, or fill it in with a marker.

Suggested Tools:
- 1.2mm writer pen
- .5mm writer pen

Lettering WORKSHOP FOR *Crafters*

M M ___ ___ N N ___ ___
O O ___ ___ P P ___ ___
Q Q ___ ___ R R ___ ___
S S ___ ___ T T ___ ___
U U ___ ___ V V ___ ___
W W ___ ___ X X ___ ___
Y Y ___ ___ Z Z ___ ___

VAUDEVILLE

Ombré Letters

How to Do This Alphabet

1. Draw a basic letter in pencil.

2. Thicken the vertical lines and sides. Add serifs to the edges of the thickened sections.

3. Outline the letter in ink then erase all pencil lines. Fill the thickened spaces with two colors, blending them where they meet to create an ombré effect.

Suggested Tools:
- Any pen
- Colored pencils

Lettering WORKSHOP FOR Crafters

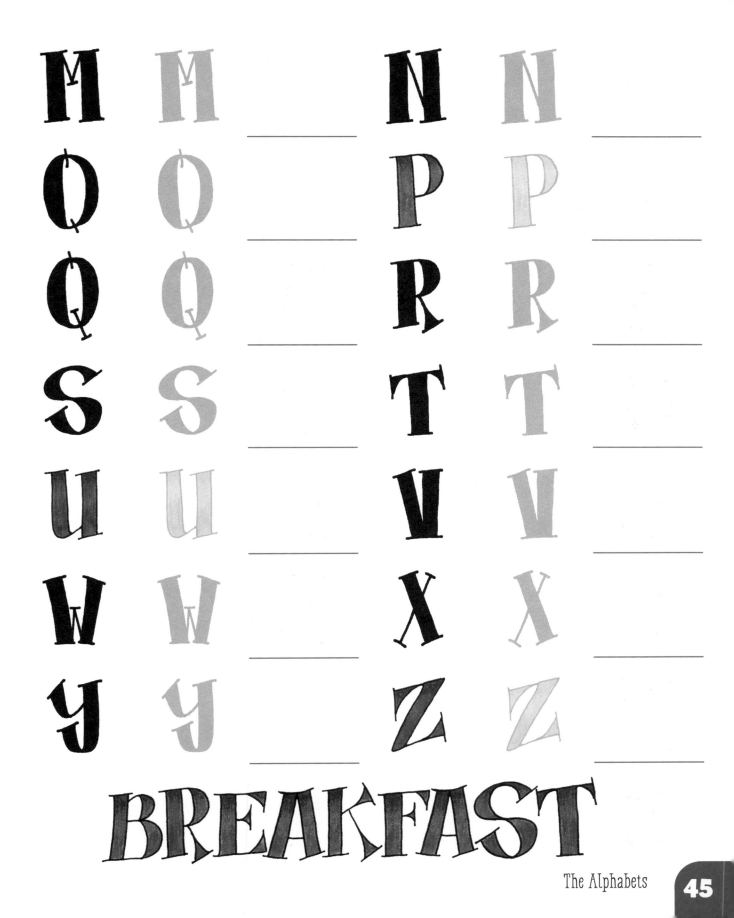

M M N N

O O P P

Q Q R R

S S T T

U U V V

W W X X

Y Y Z Z

BREAKFAST

Concave Letters

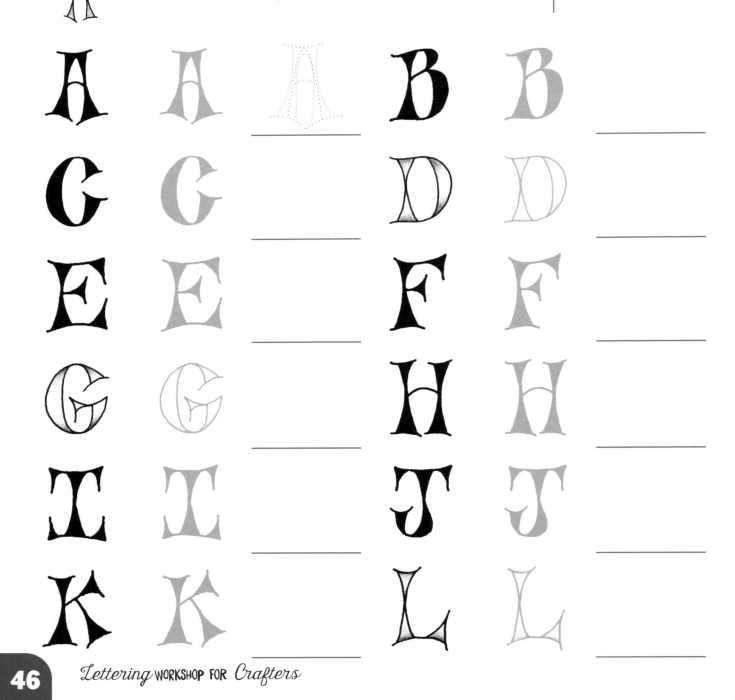

How to Do This Alphabet

1. Draw a basic letter in pencil.

2. Thicken vertical lines using concave lines that meet in the middle and split the open space. Add serifs using curved lines.

3. Outline in ink, erase pencil lines, and fill with color.

Suggested Tools:

- Any pen
- Colored pencils or markers

Lettering WORKSHOP FOR Crafters

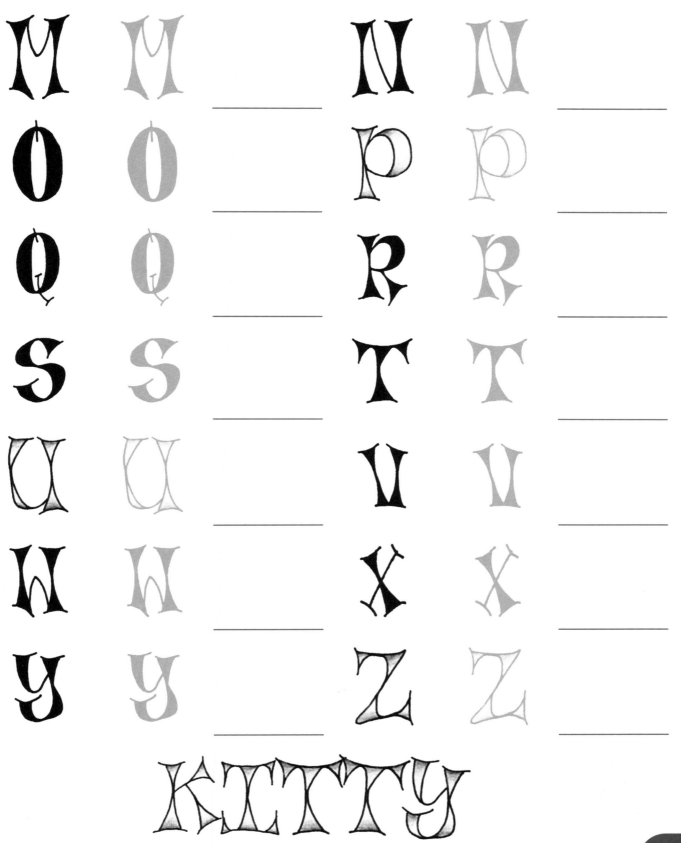

Fancy Thick Letters

How to Do This Alphabet

1. Draw a calligraphic letter in pencil.

2. Thicken the vertical lines and sides of the round letters. Try making the vertical lines slant slightly to the right.

3. Outline the letter in ink, erase the pencil lines, and fill with color.

Suggested Tools:

- Any pen

- Colored pencils or markers

A A A B B

C C D D

Ɛ Ɛ F F

G G H H

I I J J

K K Z Z

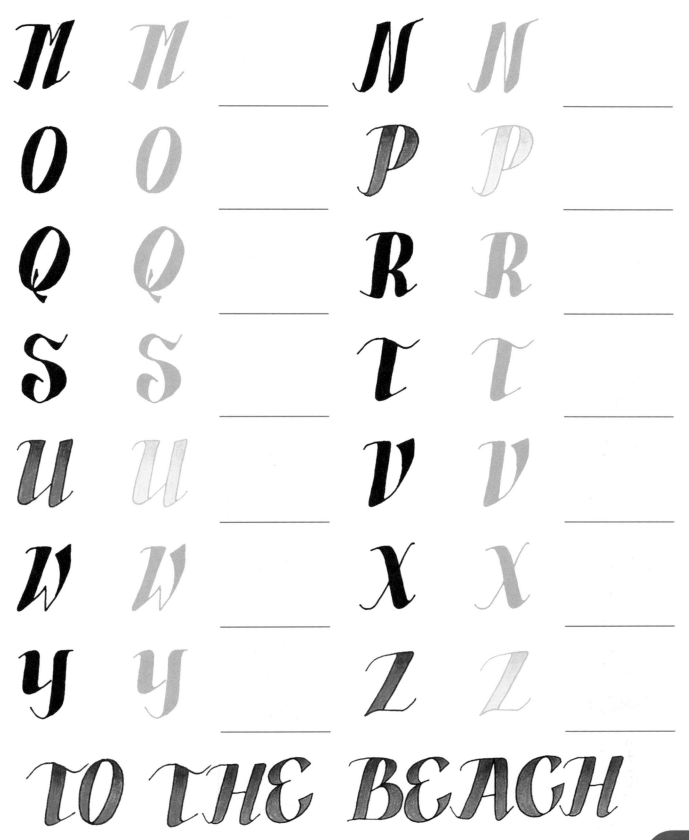

TO THE BEACH

Long Curl Letters

How to Do This Alphabet

1. Draw a serif letter with one long curl.

2. Thicken the entire letter evenly.

3. Outline in ink, erase the pencil lines, and fill with color.

Suggested Tools:

- Any pen
- Colored pencils or markers

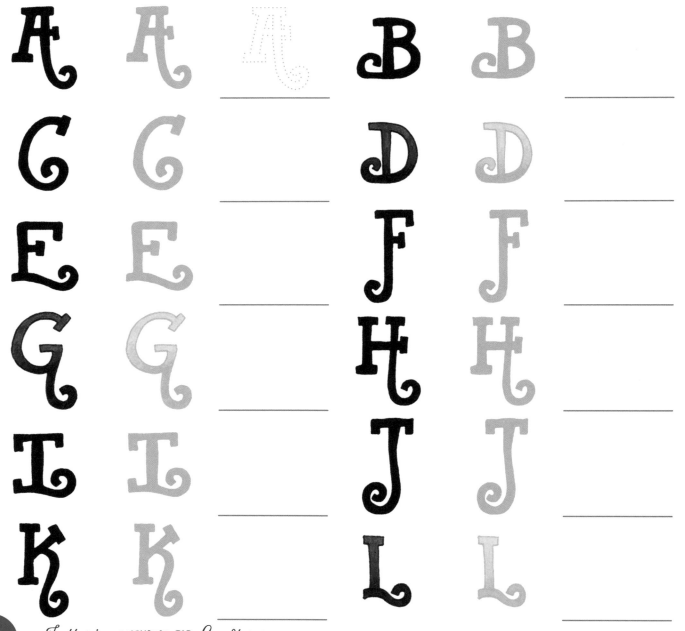

Lettering WORKSHOP FOR *Crafters*

M M _____ N N _____

O O _____ P P _____

Q Q _____ R R _____

S S _____ T T _____

U U _____ V V _____

W W _____ X X _____

Y Y _____ Z Z _____

FLOWER SHOW

Shadow Letters

How to Do This Alphabet

1. Draw a letter in pencil.

2. Hold the chisel tip at a 45° angle and go over your pencil lines.

3. Use a fine-tip pen to create the shadow. Color in the shadow areas with a bright fine-tip marker, if desired.

Suggested Tools:

- Chisel-tip pen
- Fine-tip pen
- Fine-tip marker (optional)

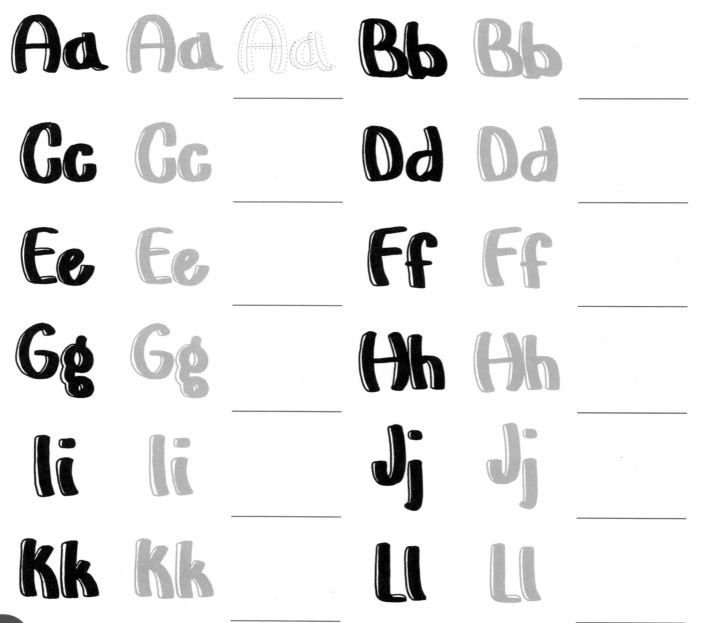

Lettering WORKSHOP FOR *Crafters*

Mm Mm _____ Nn Nn _____

Oo Oo _____ Pp Pp

Qq Qq _____ Rr Rr _____

Ss Ss _____ Tt Tt

Uu Uu _____ Vv Vv _____

Ww Ww _____ Xx Xx

Yy Yy _____ Zz Zz _____

Baby Shower

Outlined Block Letters

How to Do This Alphabet

1. Draw a letter in pencil.

2. Hold the chisel tip at a 45° angle to go over your pencil lines.

3. Go around the letter with fine-tip pen. Color in the outlined area, if desired.

Suggested Tools:

- Chisel-tip pen
- Fine-tip pen
- Colored pencils or markers (optional)

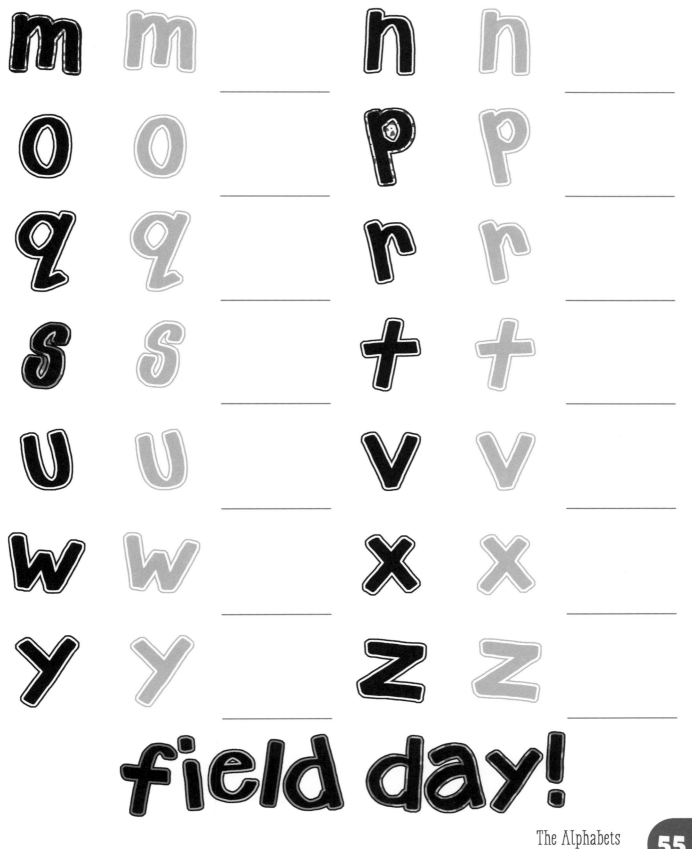

m m _____ n n _____

o o _____ p p _____

q q _____ r r _____

s s _____ t t _____

u u _____ v v _____

w w _____ x x _____

y y _____ z z _____

field day!

Zag Along Letters

How to Do This Alphabet

1. Draw a letter in pencil.

2. Begin at the top and zigzag down one side.

3. Connect at the top and zigzag down the other side. Outline the letter with a .05mm fine-tip pen and erase all pencil lines.

Suggested Tool:
- .05mm fine-tip pen

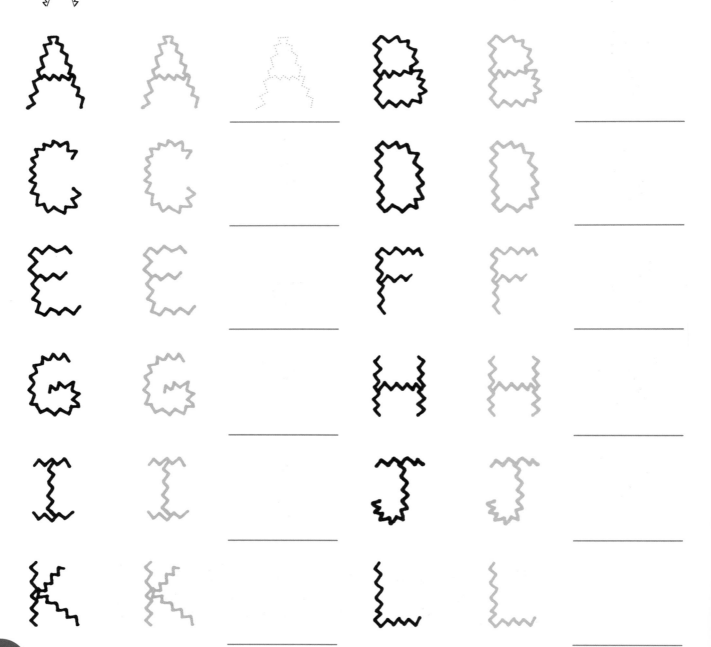

Lettering WORKSHOP FOR *Crafters*

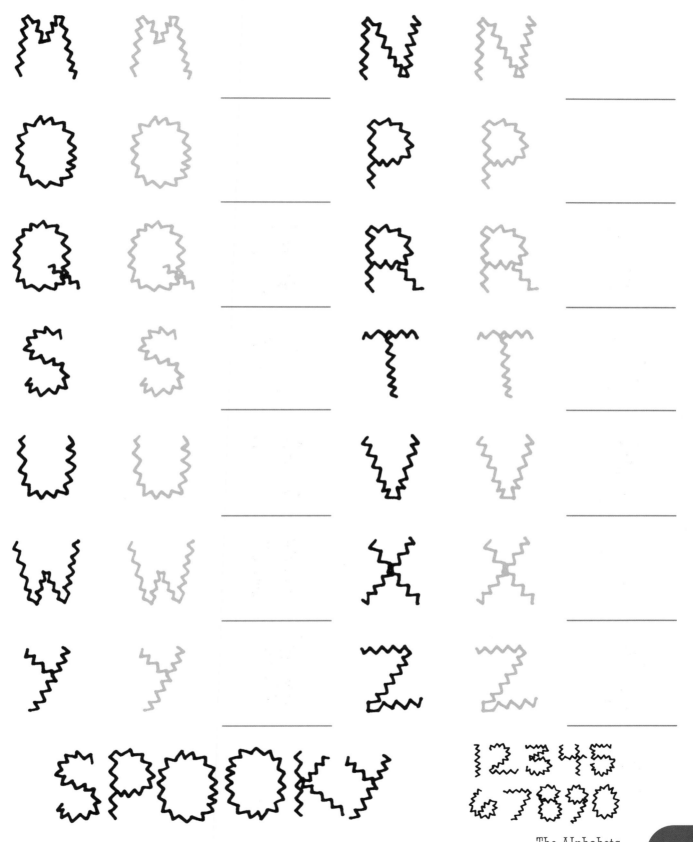

Shaky Letters

How to Do This Alphabet

1. Draw a serif letter in pencil.

2. Draw two parallel wavy lines over the letter's lines. Make the serifs curved.

3. Outline the letter carefully in ink, keeping double lines evenly spaced. Erase all pencil lines and fill with color.

Suggested Tools:
- Any pen
- Colored pencils or markers

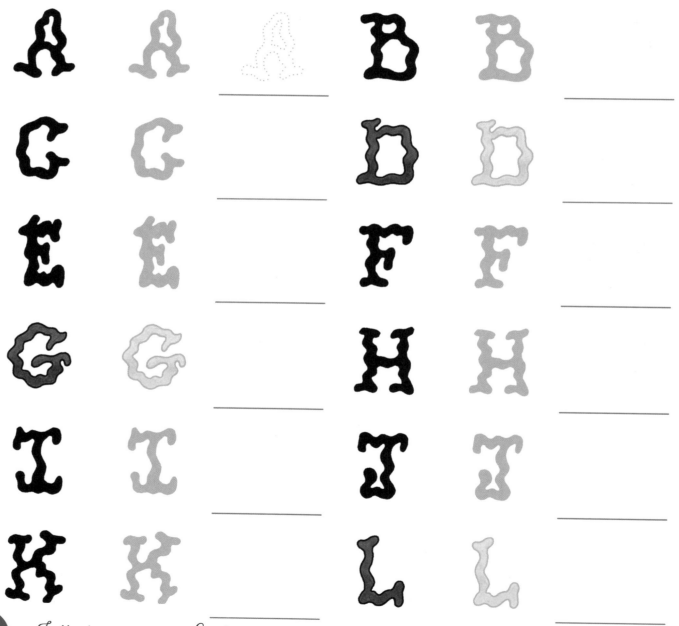

Lettering WORKSHOP FOR *Crafters*

M M _____ N N _____

O O _____ P P _____

Q Q _____ R R _____

S S _____ T T _____

U U _____ V V _____

W W _____ X X _____

Y Y _____ Z Z _____

HAUNTED HOUSE

Sloppy Letters

How to Do This Alphabet

1. Draw a sloppy letter in pencil. Make the letter asymmetrical and slightly shaky.

2. Thicken the entire letter with lines around the original lines.

3. Outline the letter messily with ink, erase all pencil lines, and fill with color.

Suggested Tools:

- Any pen

- Colored pencils or markers

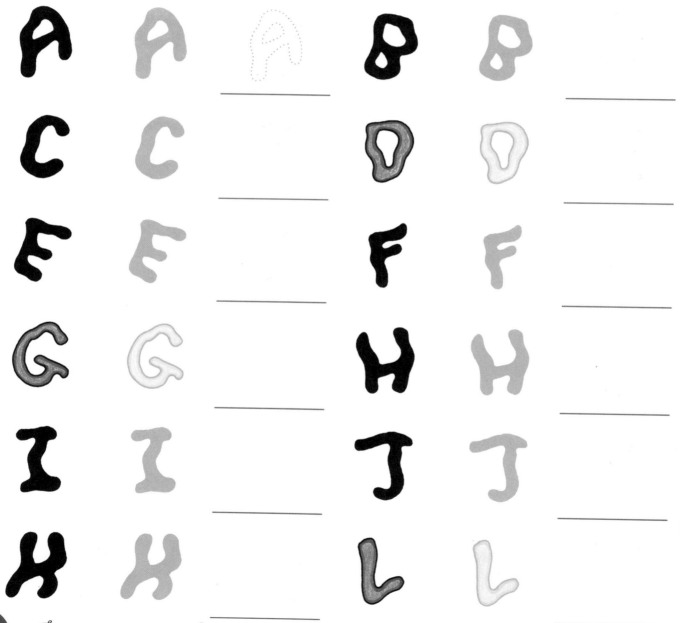

Lettering WORKSHOP FOR *Crafters*

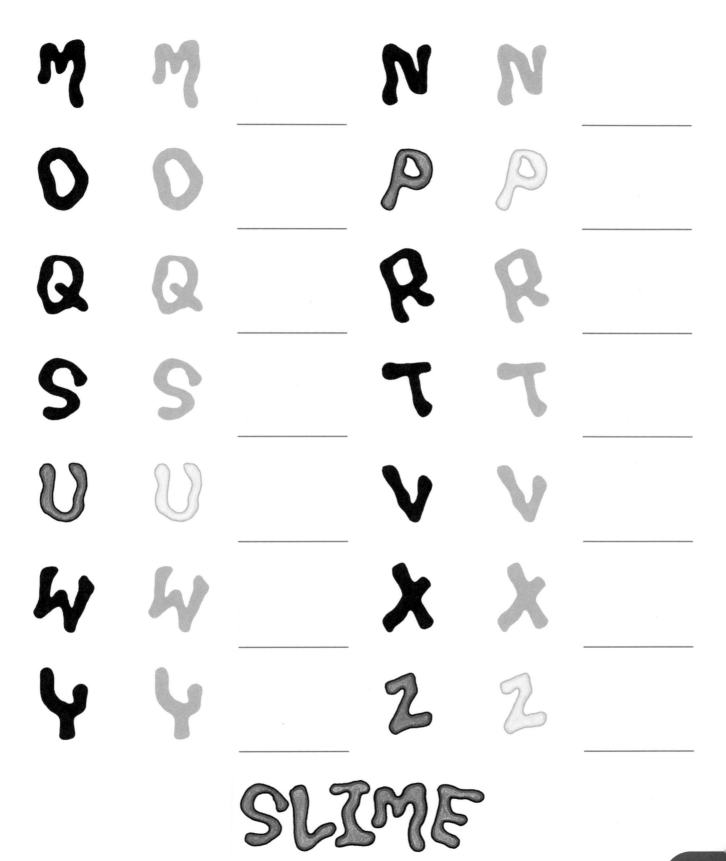

M M _____ N N _____

O O _____ P P _____

Q Q _____ R R _____

S S _____ T T _____

U U _____ V V _____

W W _____ X X _____

Y Y _____ Z Z _____

SLIME

Triangular Color Letters

How to Do This Alphabet

1. Draw a letter in pencil.
2. Add a triangle when outlining with a fine-tip pen.
3. Erase all pencil lines and fill with colors or patterns.

Suggested Tools:
- Fine-tip pen
- Colored pencils or markers

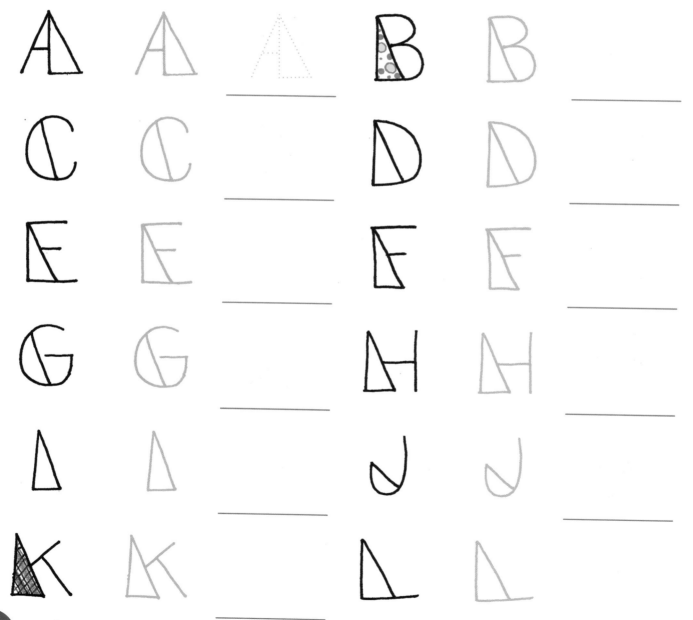

Lettering WORKSHOP FOR *Crafters*

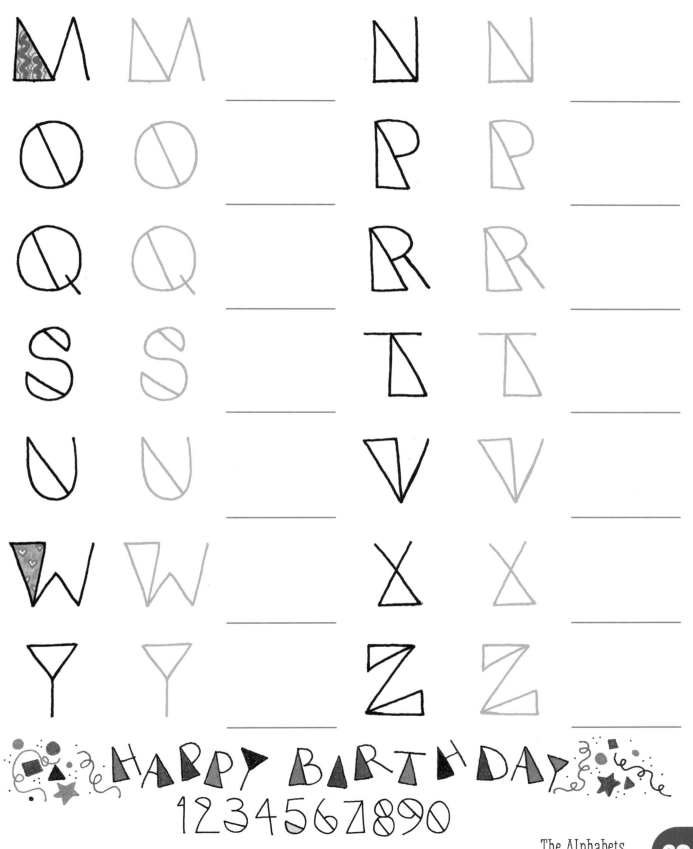

M M ___ N N ___

O O ___ P P ___

Q Q ___ R R ___

S S ___ T T ___

U U ___ V V ___

W W ___ X X ___

Y Y ___ Z Z ___

HAPPY BARTHDAY
1234567890

In-Gear Letters

How to Do This Alphabet

1. Draw a basic letter in pencil, making one vertical section very thick.

2. Make the other lines of the letter just a little wider. Add spikes on narrow areas and holes in the main thick areas.

3. Outline in ink, erase all pencil lines, and fill with color.

Suggested Tools:

- Any pen
- Colored pencils or markers

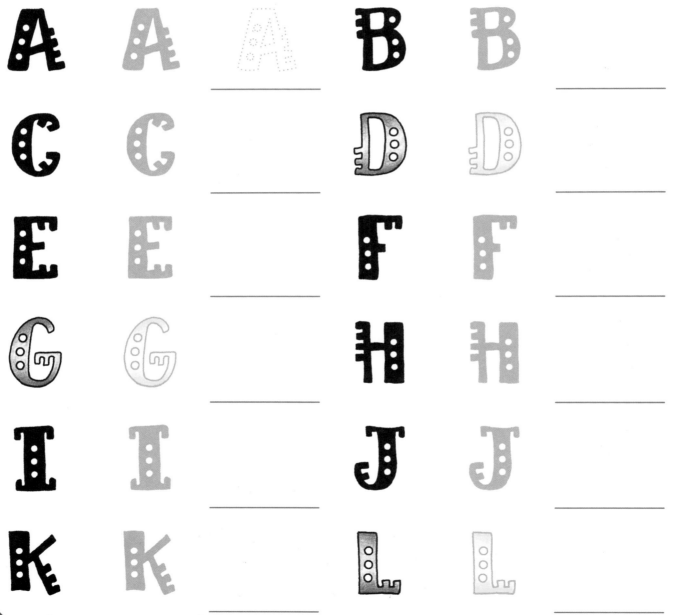

Lettering WORKSHOP FOR *Crafters*

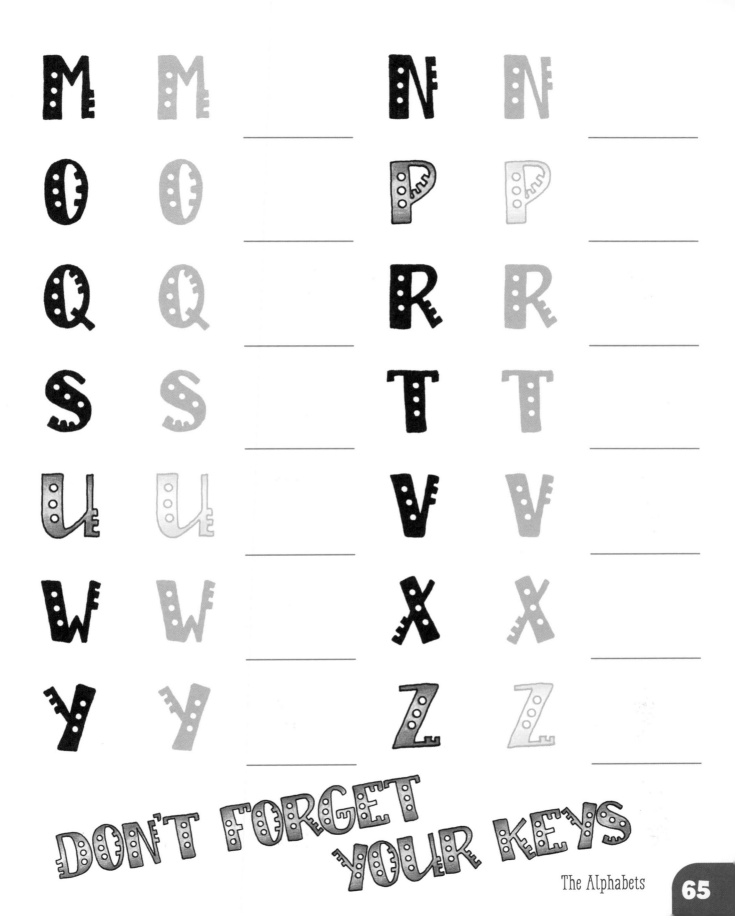

M M _____ N N _____

O O _____ P P _____

Q Q _____ R R _____

S S _____ T T _____

U U _____ V V _____

W W _____ X X _____

Y Y _____ Z Z _____

DON'T FORGET YOUR KEYS

The Alphabets

Dotted 3D Letters

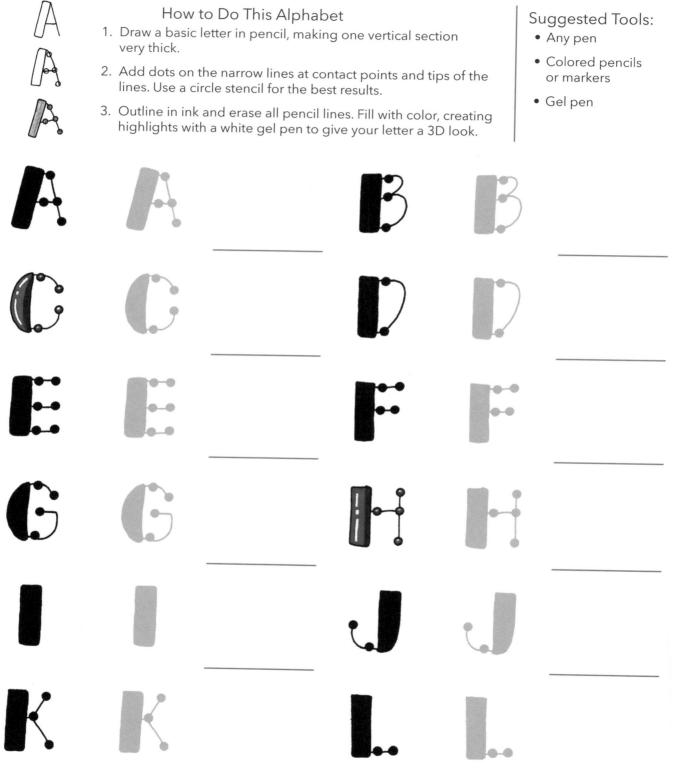

How to Do This Alphabet

1. Draw a basic letter in pencil, making one vertical section very thick.

2. Add dots on the narrow lines at contact points and tips of the lines. Use a circle stencil for the best results.

3. Outline in ink and erase all pencil lines. Fill with color, creating highlights with a white gel pen to give your letter a 3D look.

Suggested Tools:

- Any pen
- Colored pencils or markers
- Gel pen

Lettering WORKSHOP FOR *Crafters*

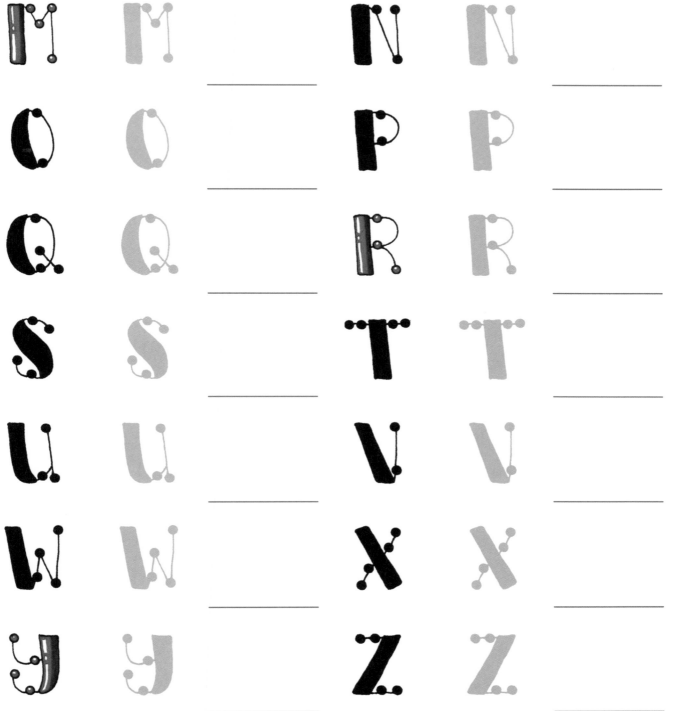

M M _____ N N _____

O O _____ P P _____

Q Q _____ R R _____

S S _____ T T _____

U U _____ V V _____

W W _____ X X _____

Y Y _____ Z Z _____

BEAD PARTY

Broken Letters

How to Do This Alphabet

1. Draw a basic letter in pencil, making one vertical section very thick. Add serifs to the other lines.

2. Draw two zigzags through the thick section and slightly thicken the other lines.

3. Outline in ink, erase all pencil lines, and fill with color.

Suggested Tools:
- Any pen
- Colored pencils or markers

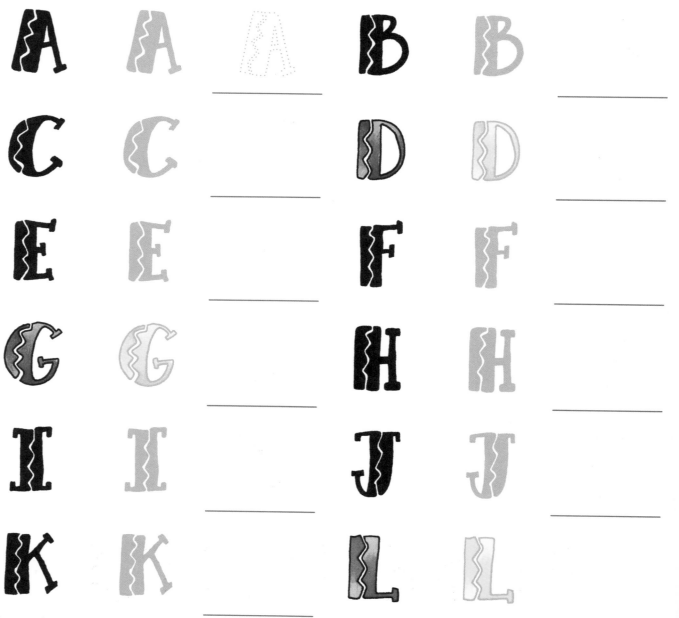

Lettering WORKSHOP FOR *Crafters*

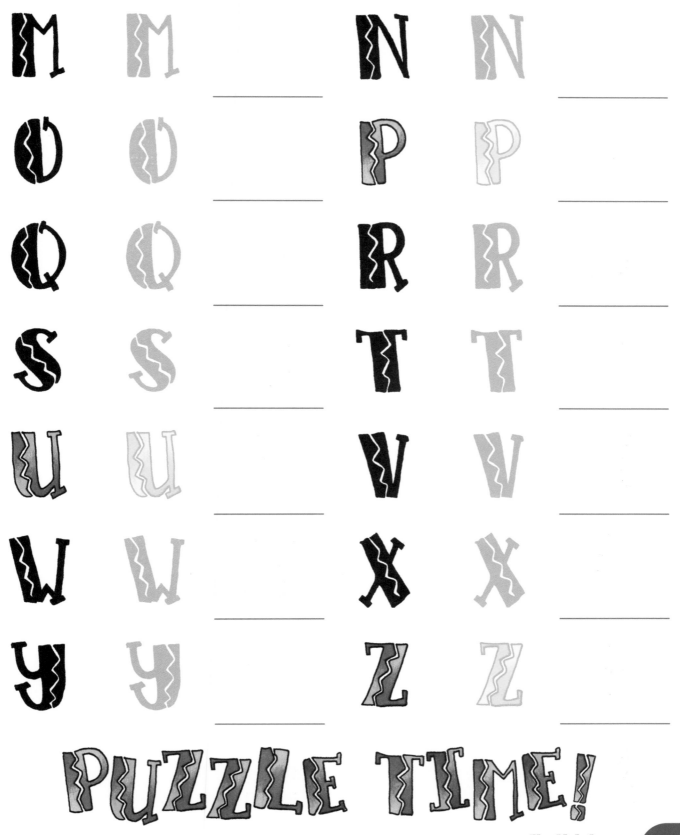

M M ___ N N ___

O O ___ P P ___

Q Q ___ R R ___

S S ___ T T ___

U U ___ V V ___

W W ___ X X ___

Y Y ___ Z Z ___

PUZZLE TIME!

Line & Dot Letters

How to Do This Alphabet

1. Draw a basic letter in pencil, making one vertical section very thick.

2. Draw a parallel vertical line next to the thick section. Add a dot to the end of one line and serif on the ends of the other lines.

3. Outline in ink, erase all pencil lines, and fill with color.

Suggested Tools:
- Any pen
- Colored pencils or markers

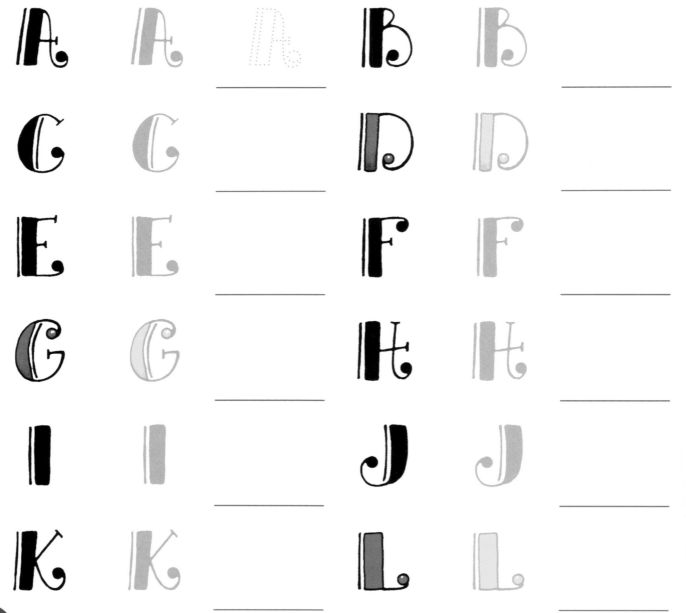

Lettering WORKSHOP FOR *Crafters*

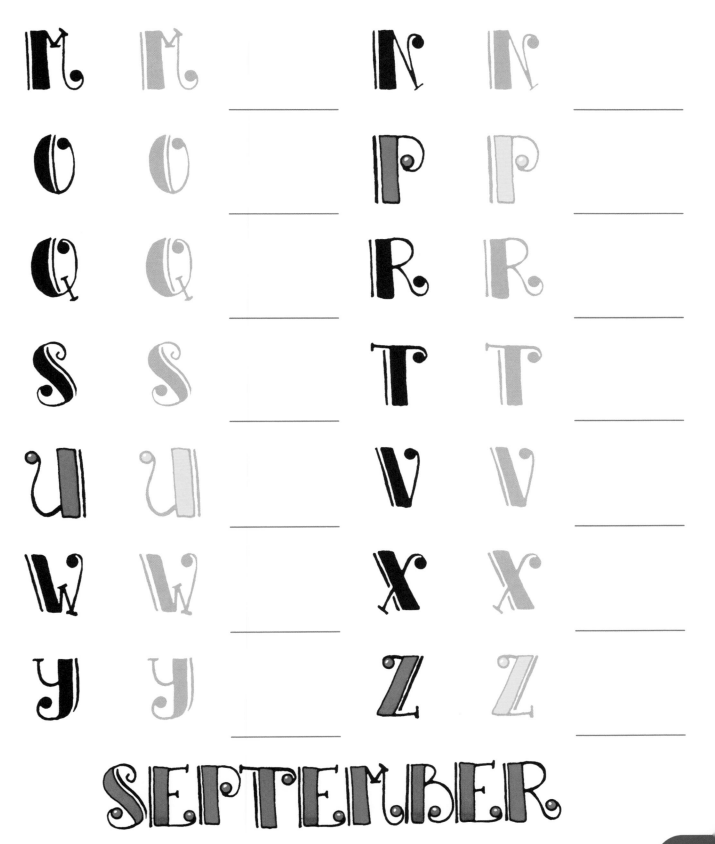

Coil Letters

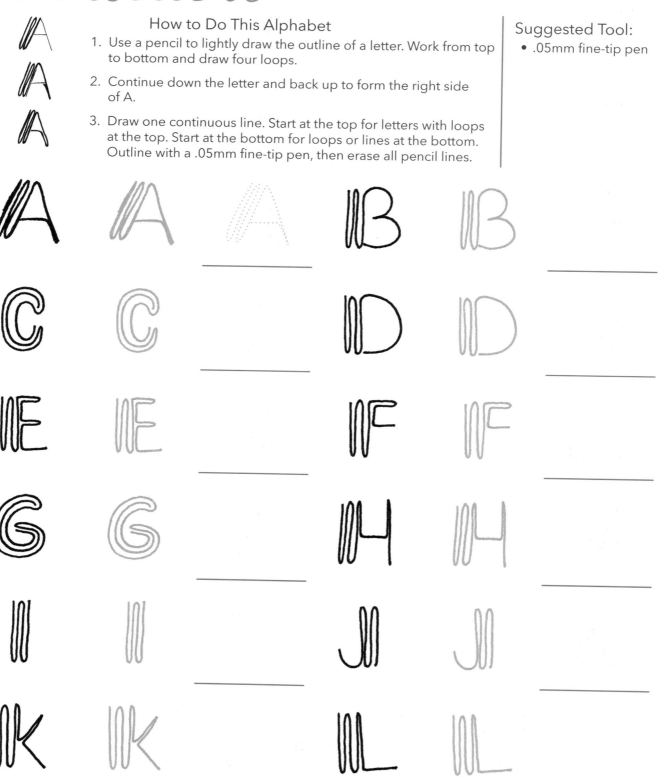

How to Do This Alphabet

1. Use a pencil to lightly draw the outline of a letter. Work from top to bottom and draw four loops.

2. Continue down the letter and back up to form the right side of A.

3. Draw one continuous line. Start at the top for letters with loops at the top. Start at the bottom for loops or lines at the bottom. Outline with a .05mm fine-tip pen, then erase all pencil lines.

Suggested Tool:

- .05mm fine-tip pen

Lettering WORKSHOP FOR *Crafters*

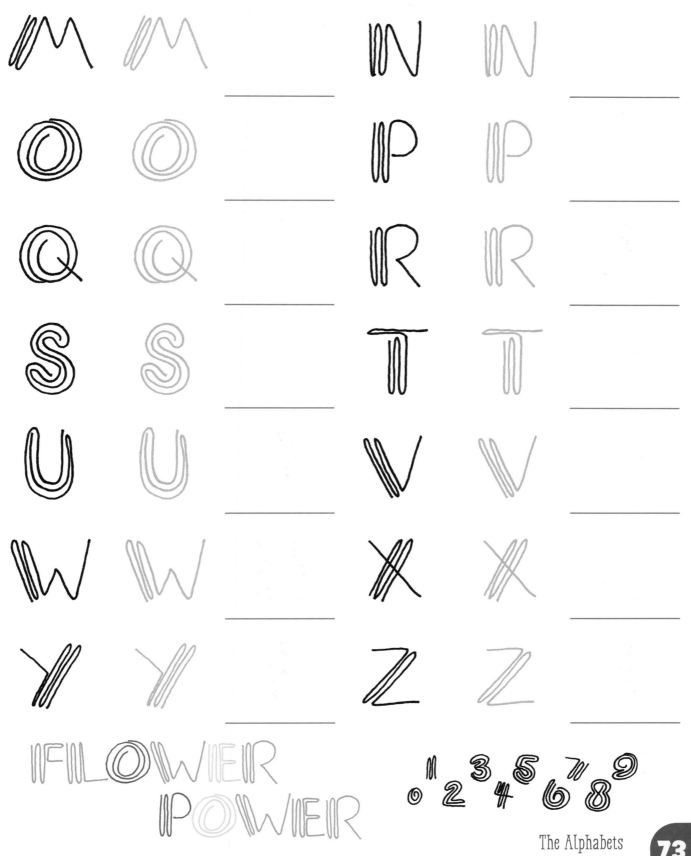

FLOWER
POWER

0 1 2 3 4 5 6 7 8 9

Spiky Letters

How to Do This Alphabet

1. Draw a basic letter in pencil. Make one or two vertical sections into long triangles.

2. Add a parallel line next to the triangles. Extend other lines through parallel lines and triangles.

3. Outline in ink, erase all pencil lines, and fill with color.

Suggested Tools:

- Any pen
- Colored pencils or markers

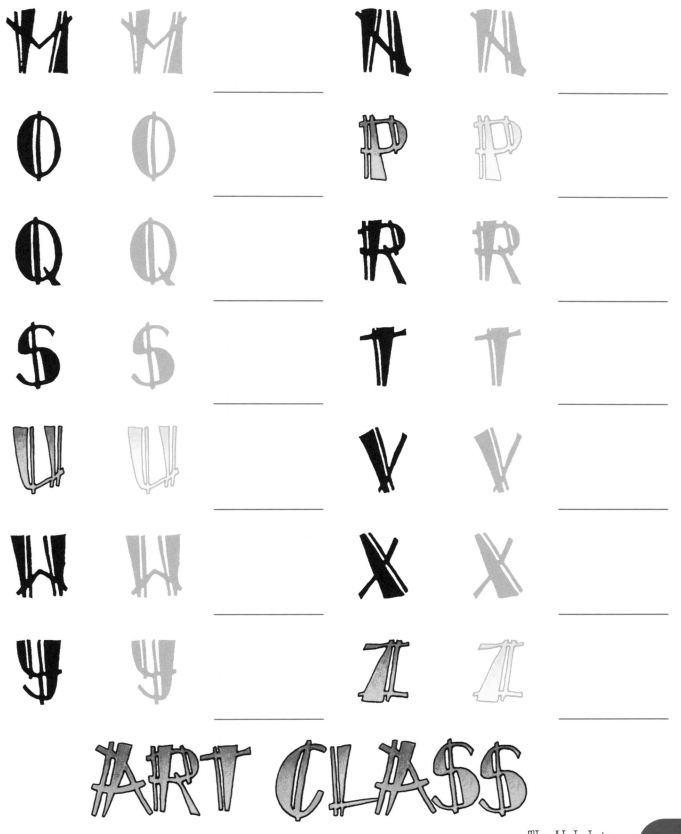

M M _____ N N _____

O O _____ P P _____

Q Q _____ R R _____

S S _____ T T _____

U U _____ V V _____

W W _____ X X _____

Y Y _____ Z Z _____

ART CLASS

Prickly Letters

How to Do This Alphabet

1. Draw a basic letter in pencil, making one vertical section very thick. Add serifs to the ends of the other lines.

2. Slightly thicken the single lines and add a row of triangles to the side of the thick part.

3. Outline in ink, erase all pencil lines, and fill with color.

Suggested Tools:
- Any pen
- Colored pencils or markers

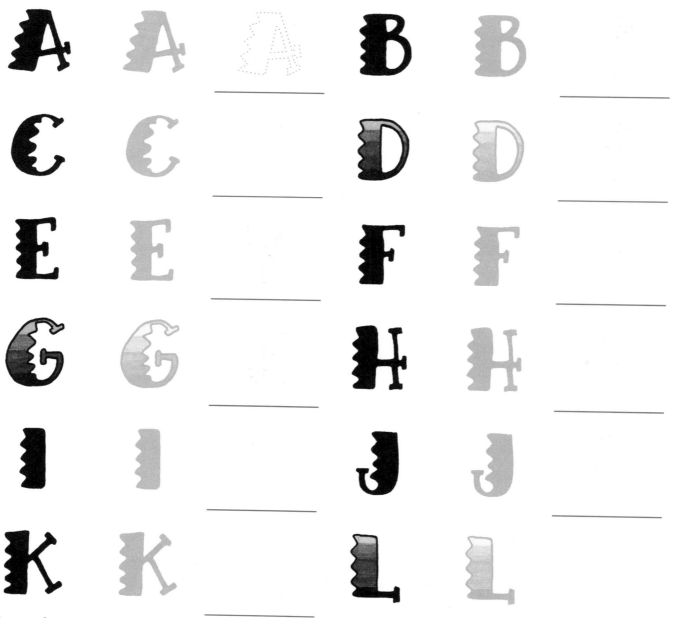

Lettering WORKSHOP FOR *Crafters*

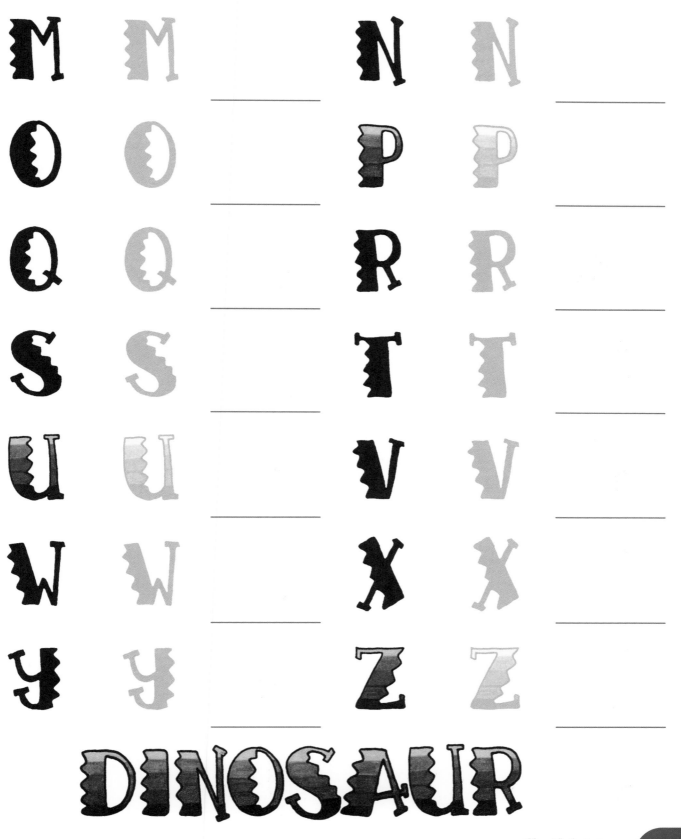

M M ____

N N ____

O O ____

P P ____

Q Q ____

R R ____

S S ____

T T ____

U U ____

V V ____

W W ____

X X ____

Y Y ____

Z Z ____

DINOSAUR

Swirl & Dot Letters

How to Do This Alphabet

1. Draw a basic letter in pencil, making one vertical section very thick.

2. Make one line end in a swirl and add serifs to other lines. Add four dots next to the thick part.

3. Outline in ink, erase all pencil lines, and fill with color.

Suggested Tools:

- Any pen
- Colored pencils or markers

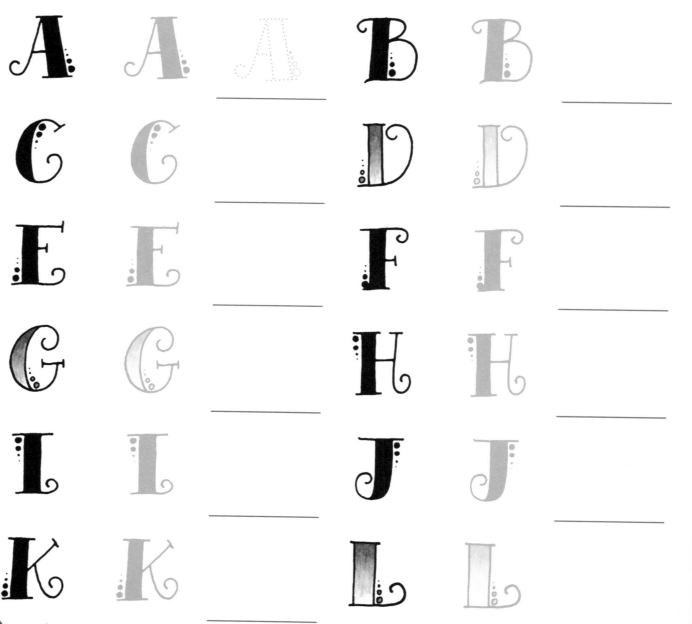

Lettering WORKSHOP FOR *Crafters*

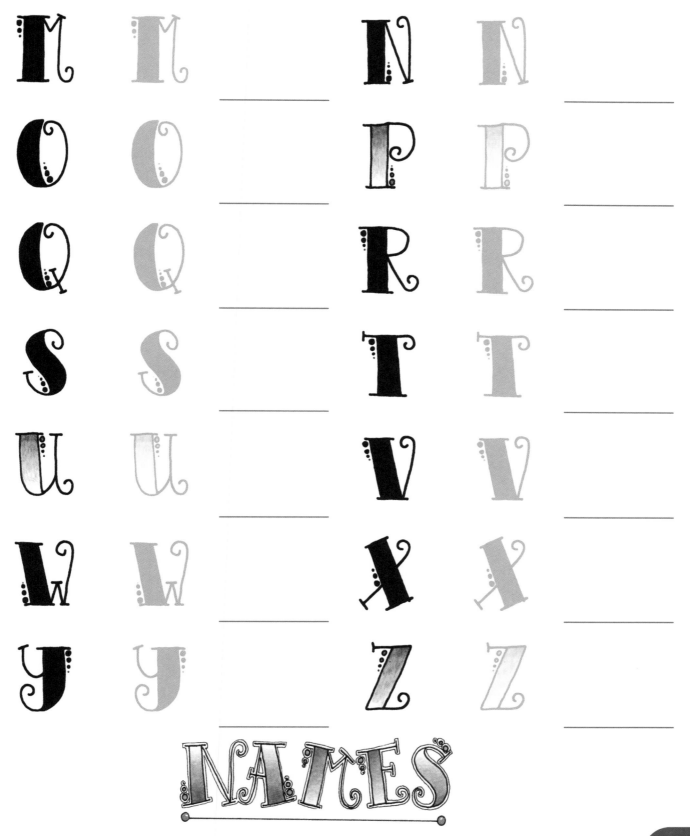

Circled Letters

How to Do This Alphabet

1. Draw a basic letter in pencil. Make the letter roomy enough to accommodate circles without crowding.

2. Add circles to the tips and contact points. Circle stencils work best.

3. Outline in ink and erase all pencil lines. Fill with color, using a white gel pen to create highlights.

Suggested Tools:

- Any pen
- Colored pencils or markers
- Gel pen

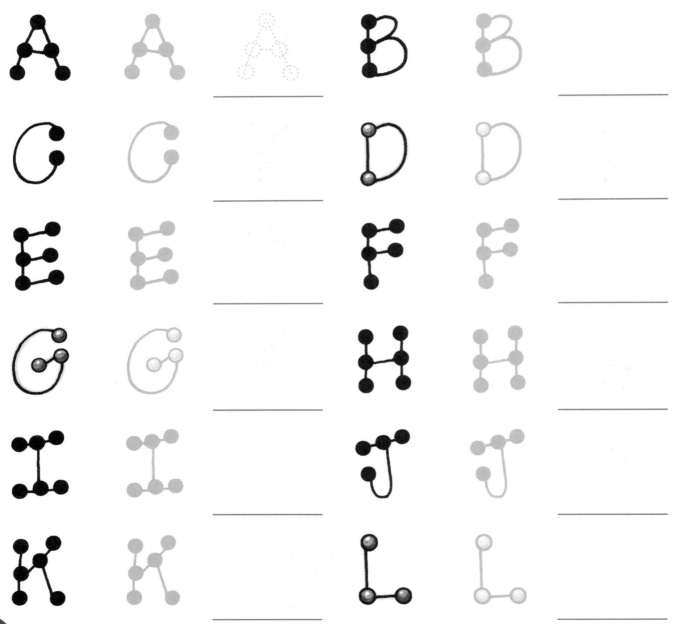

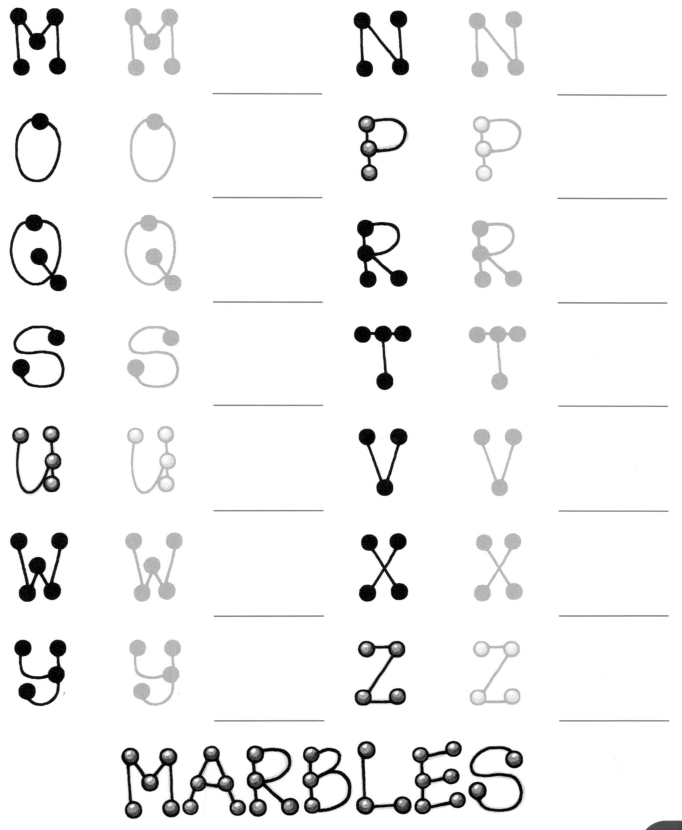

Bubble Garden Letters

How to Do This Alphabet
1. Draw a basic letter in pencil.
2. Draw a rounded outline around the letter with a gel pen.
3. Add the flower details.

Suggested Tools:
- .7mm gel pens

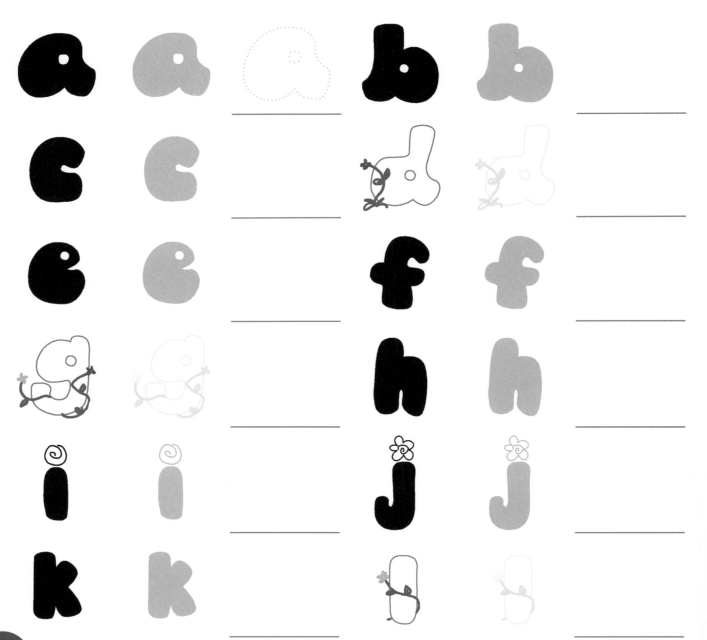

Lettering WORKSHOP FOR *Crafters*

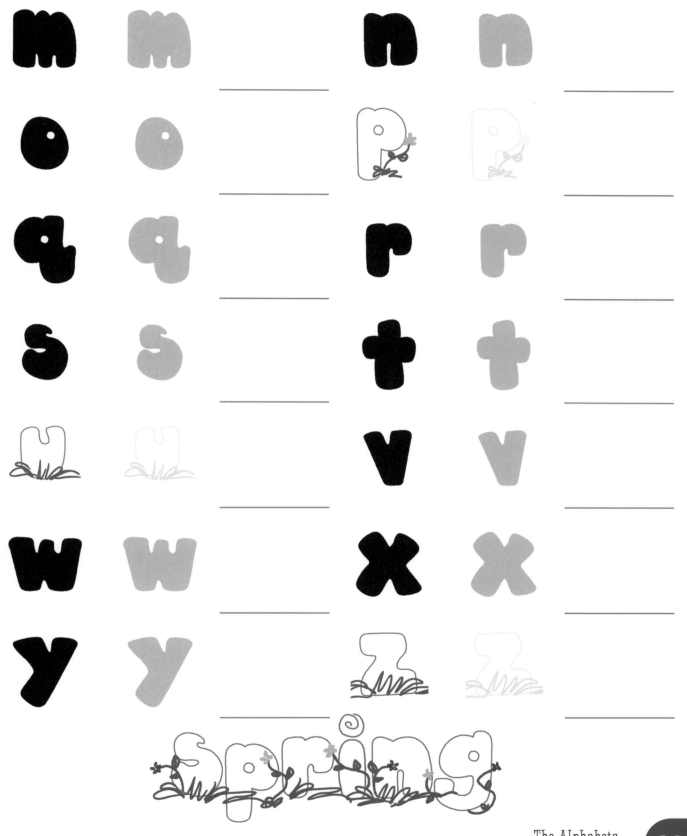

Polka-Dot Block Letters

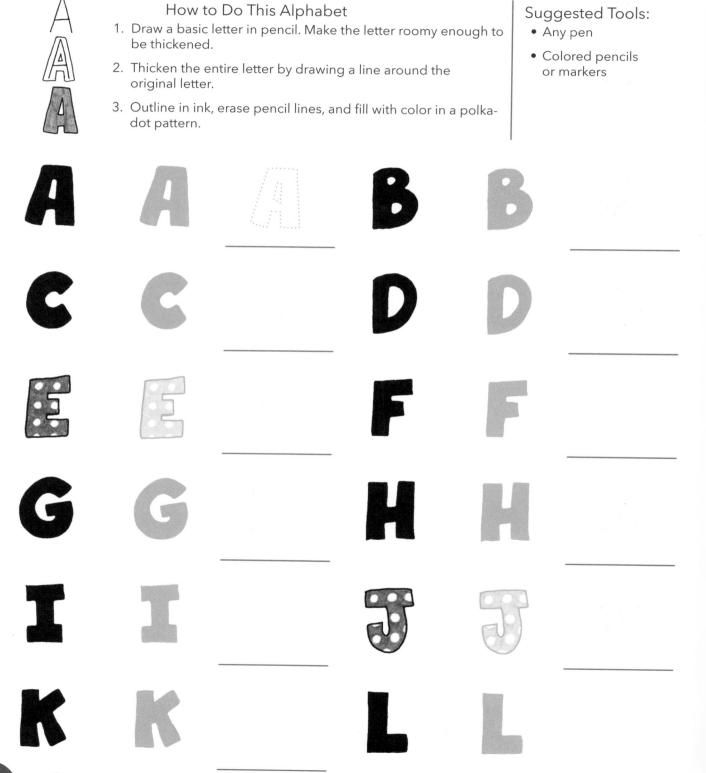

How to Do This Alphabet

1. Draw a basic letter in pencil. Make the letter roomy enough to be thickened.

2. Thicken the entire letter by drawing a line around the original letter.

3. Outline in ink, erase pencil lines, and fill with color in a polka-dot pattern.

Suggested Tools:

- Any pen

- Colored pencils or markers

Lettering WORKSHOP FOR *Crafters*

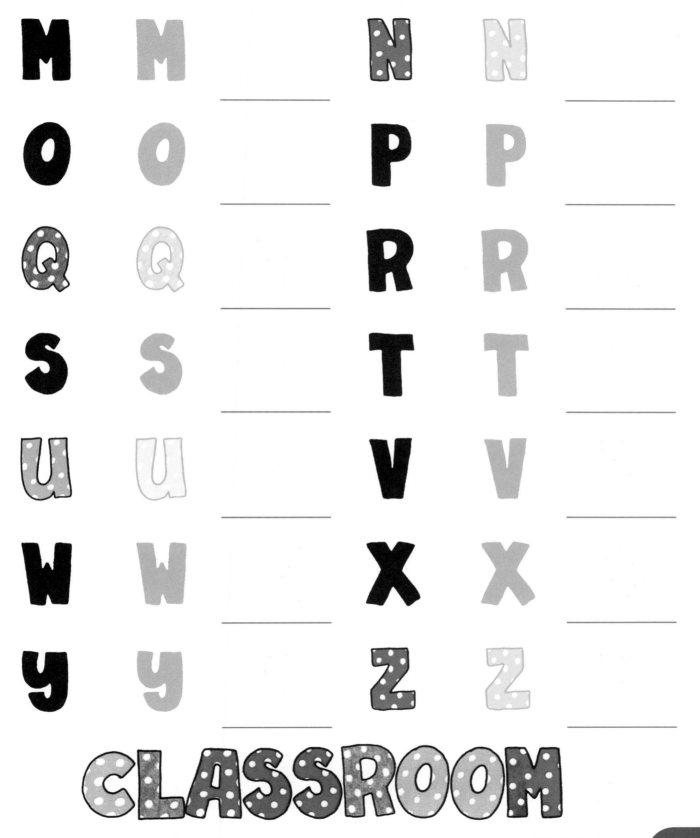

M M _____

N N _____

O O

P P _____

Q Q _____

R R

S S _____

T T _____

U U

V V _____

W W _____

X X

Y Y _____

Z Z _____

CLASSROOM

Plaid Letters

How to Do This Alphabet

1. Draw a thickened letter in pencil.

2. Make all single lines thicker but still narrower than the thickened vertical sections.

3. Outline in ink very carefully, keeping the lines straight. Erase all pencil lines and fill with color in a plaid pattern.

Suggested Tools:

- Any pen

- Colored pencils or markers

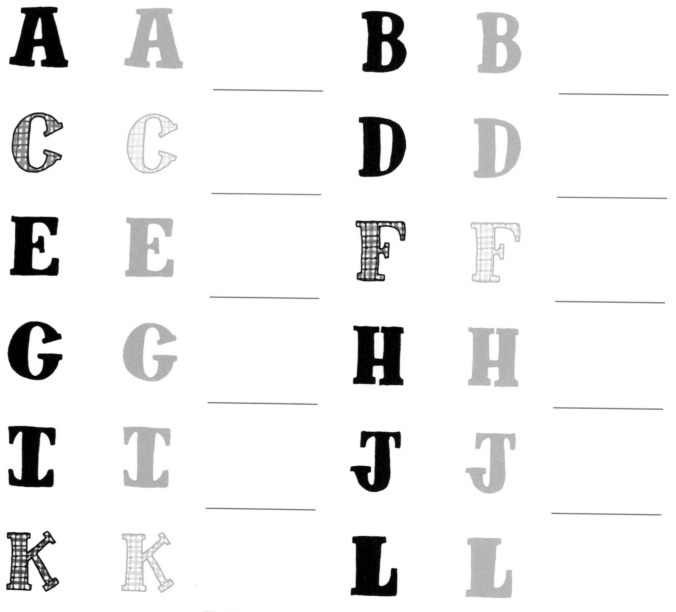

Lettering WORKSHOP FOR *Crafters*

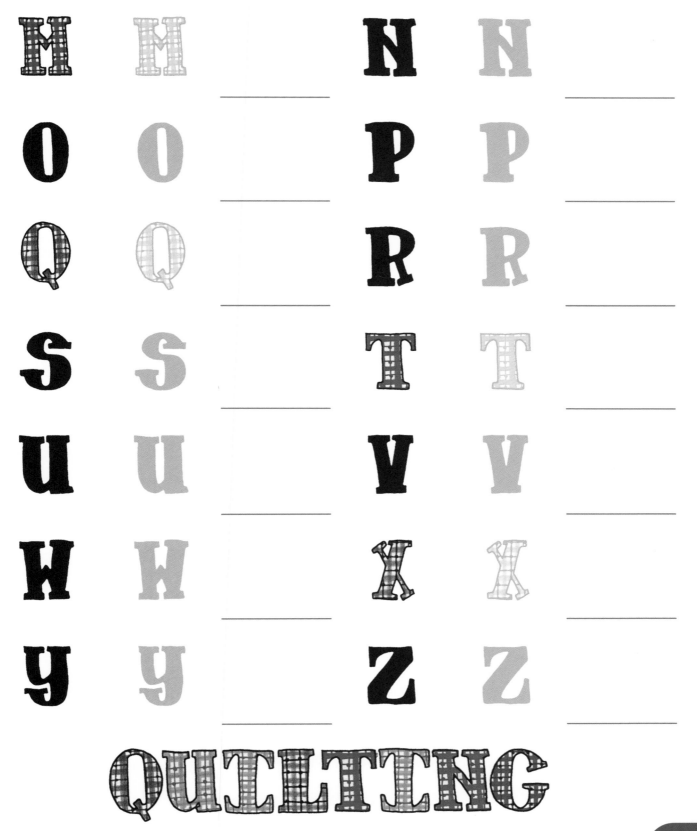

M M _____ N N _____

O O _____ P P _____

Q Q _____ R R _____

S S _____ T T _____

U U _____ V V _____

W W _____ X X _____

Y Y _____ Z Z _____

QUILTING

Angular Letters

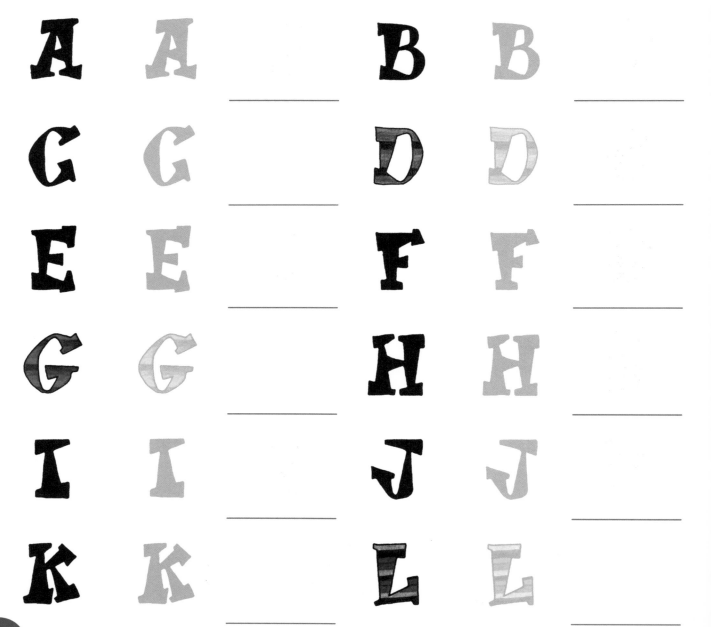

How to Do This Alphabet

1. Draw a serif letter in pencil with long serifs.

2. Turn the lines into long triangles with a blunt edge instead of points. Alternate the direction of the triangles.

3. Outline in ink, erase all pencil lines, and fill with color.

Suggested Tools:

- Any pen
- Colored pencils or markers

Lettering WORKSHOP FOR *Crafters*

M M

N N

O O

P P

Q Q

R R

S S

T T

U U

V V

W W

X X

Y Y

Z Z

FOURTH OF JULY

Gingham Letters

How to Do This Alphabet

1. Draw a letter in pencil with lines crossing each other slightly. Add crossing lines at the tips.

2. Thicken the entire letter.

3. Outline in ink, erase all pencil lines, and fill with color in a gingham pattern.

Suggested Tools:
- Any pen
- Colored pencils or markers

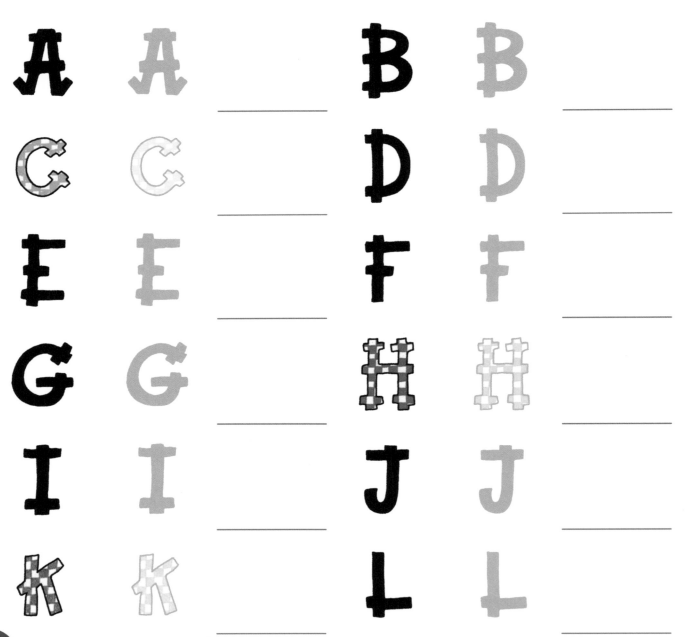

Lettering WORKSHOP FOR *Crafters*

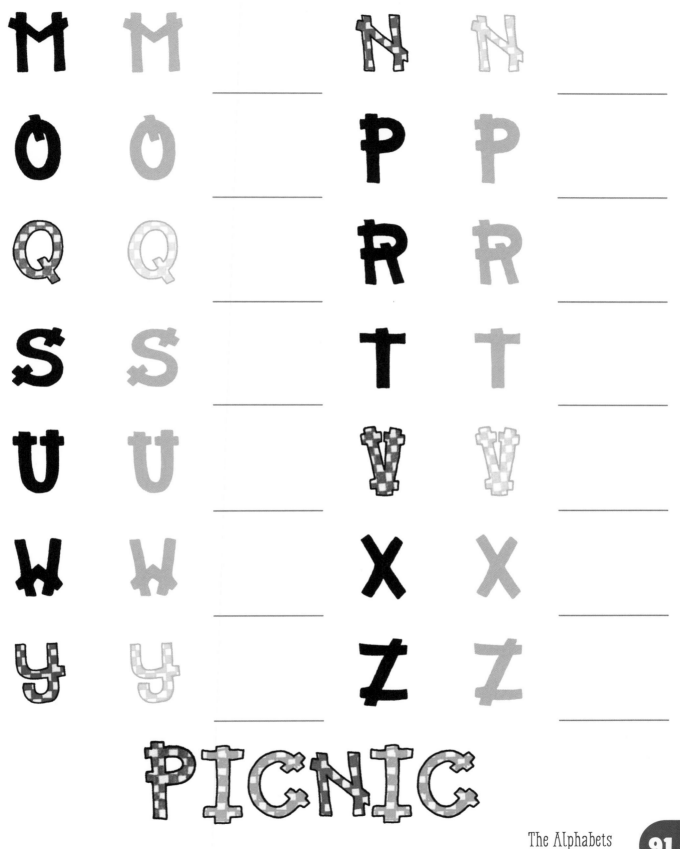

M M ____ N N ____

O O P P

Q Q R R

S S T T

U U V V

W W X X

Y Y Z Z

PICNIC

Appliqué Letters

How to Do This Alphabet

1. Draw a basic letter in pencil.

2. Beginning with the letter's straight line, make a zigzag stitch design over the pencil line. If the letter does not have a straight line, start where you began the letter.

3. Work slowly around the curves. Keep the lines even. Outline the letter with a .08mm fine pen, then erase all pencil lines.

Suggested Tool:
- .08mm fine-tip pen

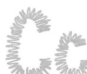

Lettering WORKSHOP FOR *Crafters*

Mm Mm Nn Nn

Oo Oo Pp Pp

Qq Qq Rr Rr

Ss Ss Tt Tt

Uu Uu Vv Vv

Ww Ww Xx Xx

Yy Yy Zz Zz

Fabric 1 2 3 4 5 6 7 8 9 0

Stitch-in-Time Letters

How to Do This Alphabet

1. Draw a basic letter in pencil.
2. Draw dashed lines over the pencil lines with a .03mm fine-tip pen.
3. Erase all pencil lines.

Suggested Tool:
- .03mm fine-tip pen

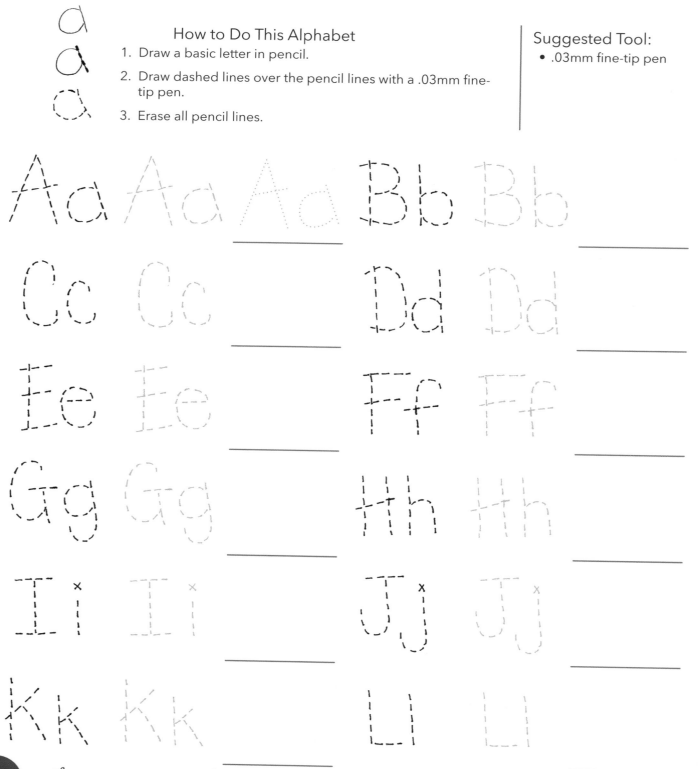

Lettering WORKSHOP FOR *Crafters*

Mm Mm _____ Nn Nn _____

Oo Oo _____ Pp Pp _____

Qq Qq _____ Rr Rr _____

Ss Ss _____ Tt Tt _____

Uu Uu _____ Vv Vv _____

Ww Ww _____ Xx Xx _____

Yy Yy _____ Zz Zz _____

Pins and Needles

Ornamental Letters

How to Do This Alphabet

1. Draw a basic letter in pencil.
2. Draw over the letter with a gel pen, adding a swirl.
3. Erase the pencil lines and add fun details.

Suggested Tool:
- .3mm gel pen

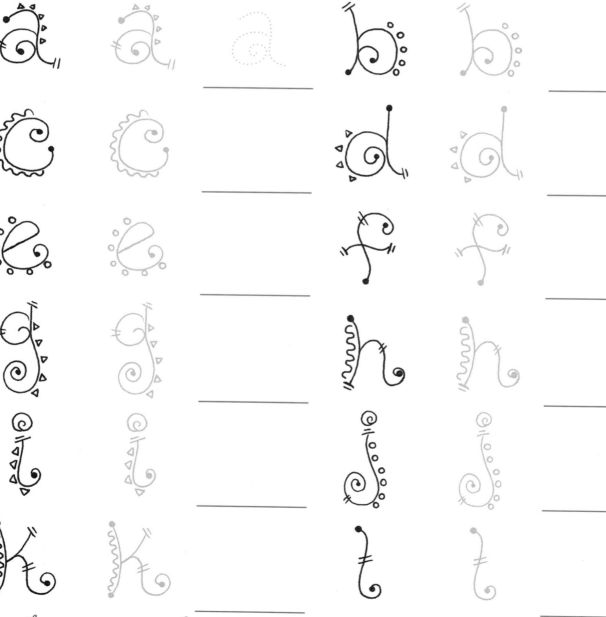

Lettering WORKSHOP FOR Crafters

m m ___ n n ___

o o ___ p p ___

t t ___ r r ___

s s ___ t t ___

u u ___ v v ___

w w ___ x x ___

y y ___ z z ___

fun with letters

Soft Ribbon Letters

How to Do This Alphabet

1. Draw a fancy letter in pencil.

2. Add a circle to the ends of all lines, and widen the lines using gentle curves that make open spaces alternating between thick and thin.

3. Outline in ink, erase all pencil lines, and fill with color.

Suggested Tools:
- Any pen
- Colored pencils or markers

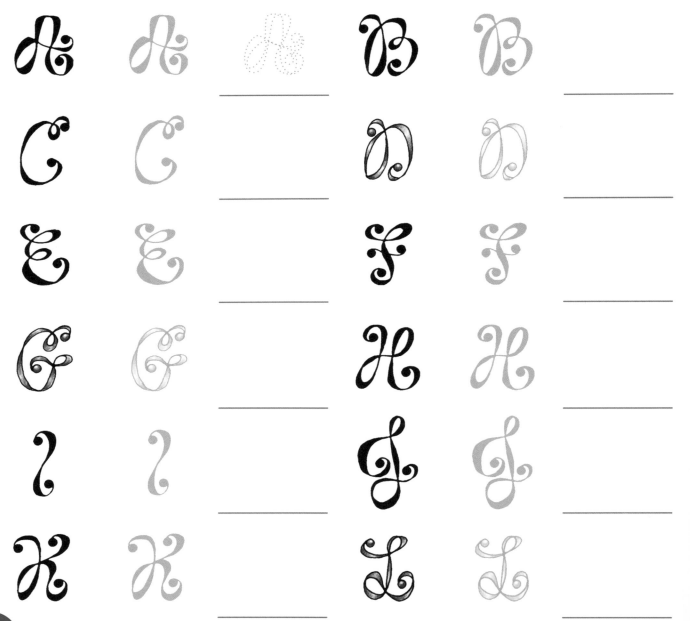

Lettering WORKSHOP FOR *Crafters*

M M _____ N N _____

O O _____ P P _____

Q Q _____ R R _____

S S _____ T T _____

U U _____ V V _____

W W _____ X X _____

Y Y _____ Z Z _____

BALLET CLASS

Angular Ribbon Letters

How to Do This Alphabet

1. Draw a fancy letter in pencil.
2. Widen the letters using angular lines with sharp points, and make open spaces, alternating between thick and thin.
3. Outline in ink, erase all pencil lines, and fill with color.

Suggested Tools:

- Any pen
- Colored pencils or markers

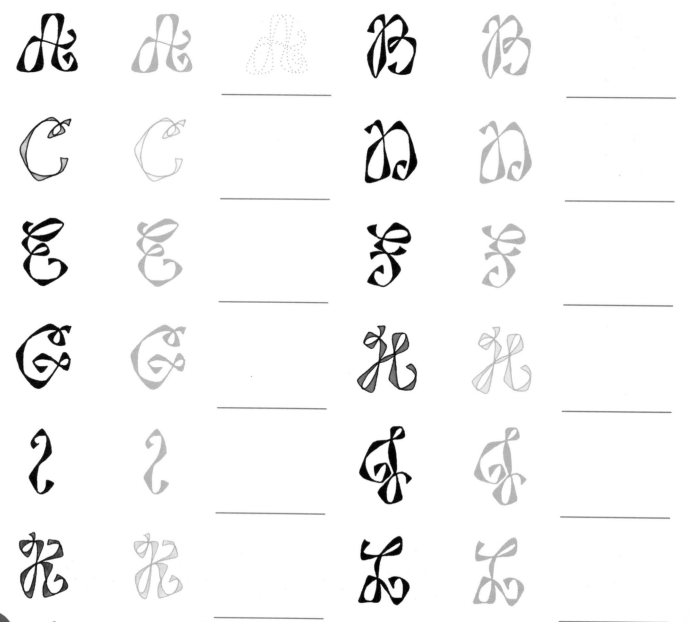

Lettering WORKSHOP FOR *Crafters*

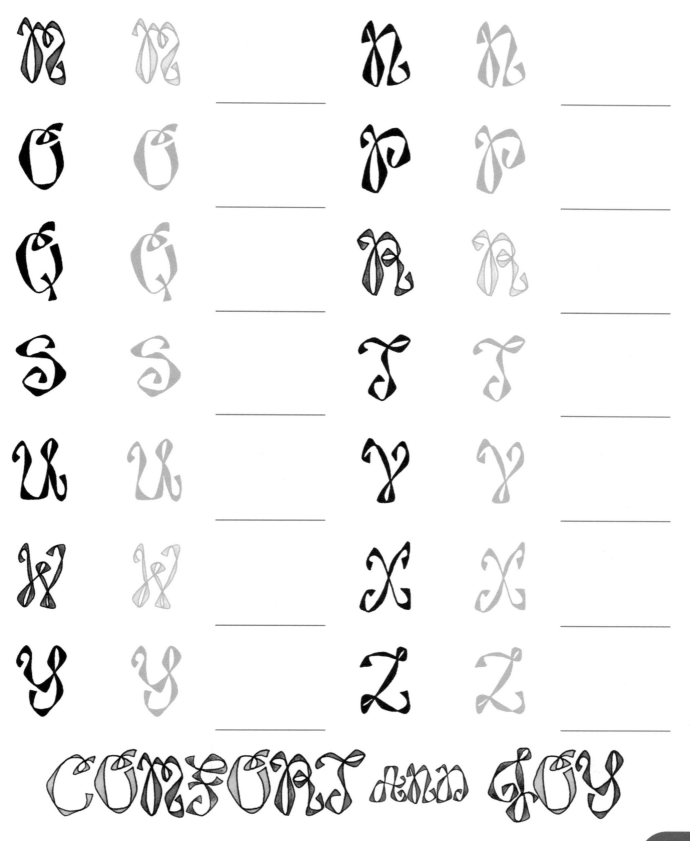

Dripping Letters

How to Do This Alphabet

1. Draw a basic letter in pencil.

2. Thicken the letter, adding edges by drawing drips at several places on the letter. Make all corners and ends round.

3. Outline in ink, erase all pencil lines, and fill with color. Use a white gel pen to add highlights.

Suggested Tools:

- Any pen
- Colored pencils or markers
- Gel pen

Lettering WORKSHOP FOR *Crafters*

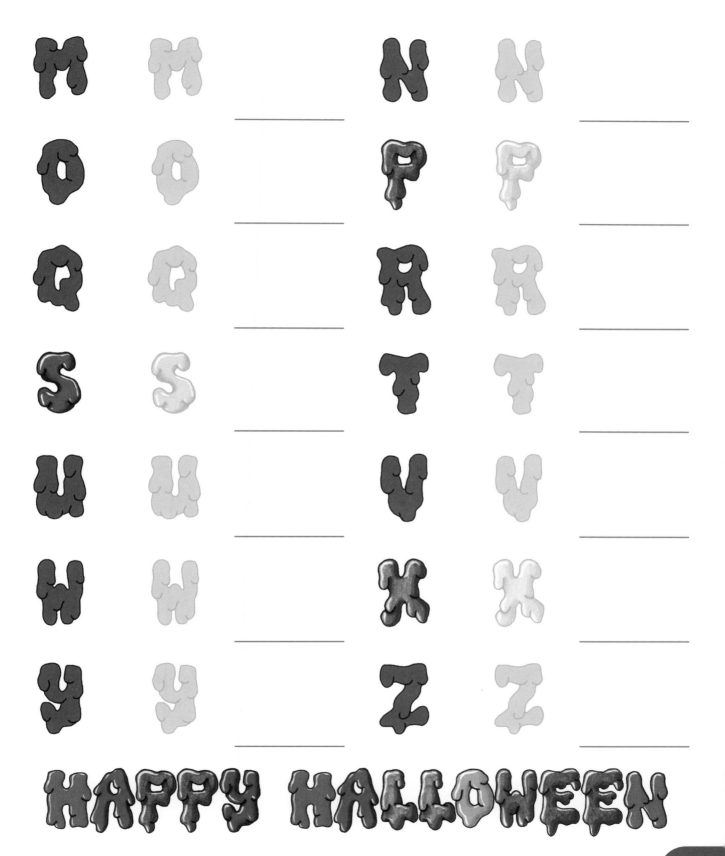

Musical Melody Letters

How to Do This Alphabet

1. Draw a basic letter in pencil.
2. Outline the letter with a .05mm writer pen and add tails.
3. Add dots and fill the letter with a colorful 1.2mm writer pen.

Suggested Tools:

- .05mm writer pen
- 1.2mm writer pen

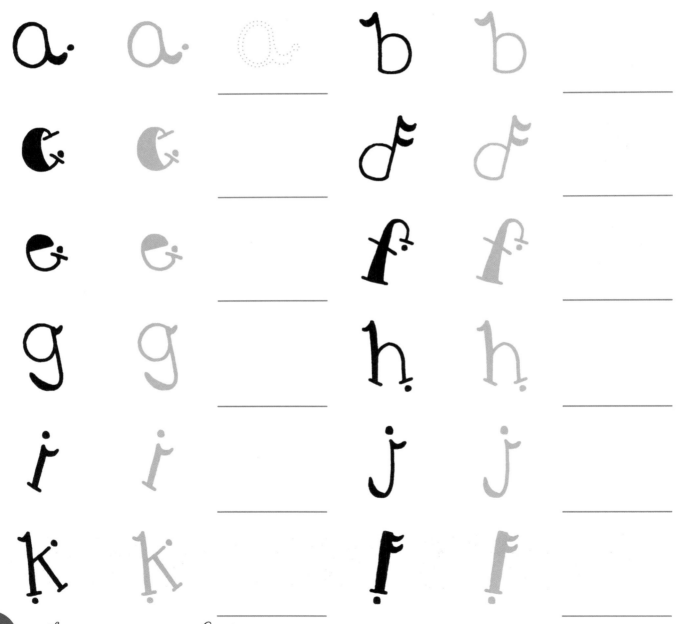

Lettering WORKSHOP FOR *Crafters*

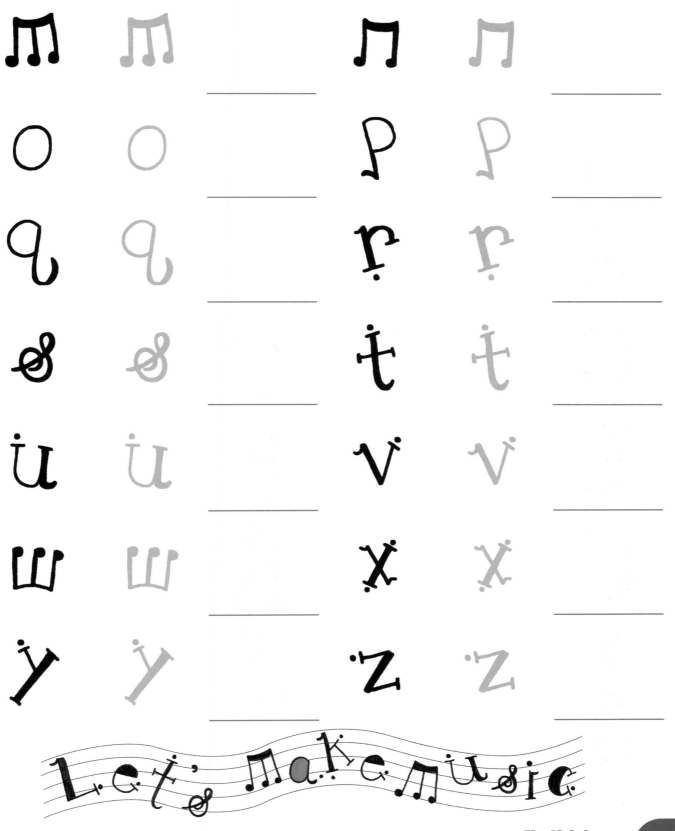

The Alphabets

Vintage Letters

How to Do This Alphabet

1. Draw a basic letter in pencil.

2. Outline the letter, thickening the vertical sections. Add serifs to the ends.

3. Fill the letters with a pen or colored pencil.

Suggested Tools:

- Any pen
- Colored pencils (optional)

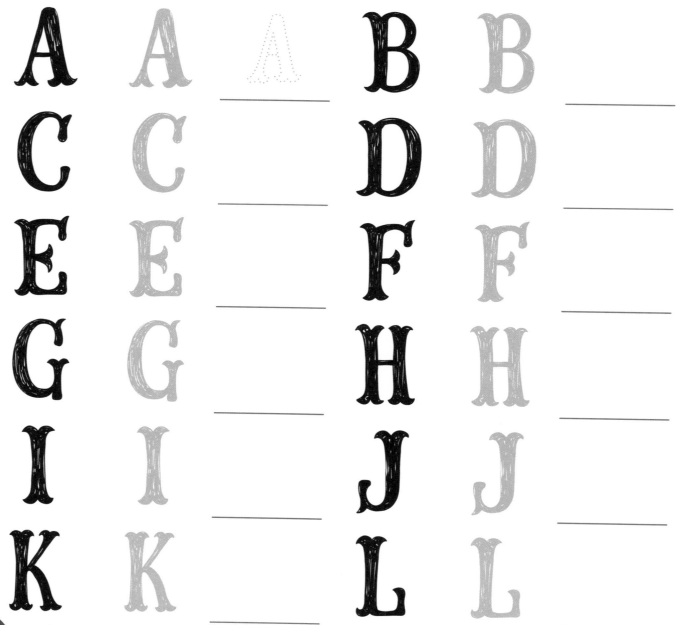

Lettering WORKSHOP FOR *Crafters*

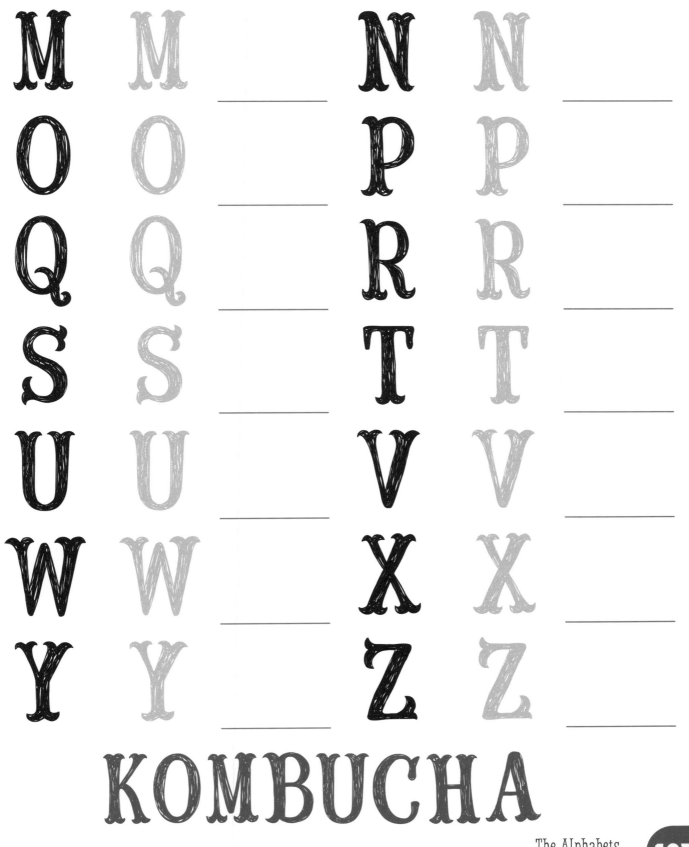

M M ___ N N ___

O O ___ P P ___

Q Q ___ R R ___

S S ___ T T ___

U U ___ V V ___

W W ___ X X ___

Y Y ___ Z Z ___

KOMBUCHA

Doodle Letters

How to Do This Alphabet

1. Draw a basic letter in pencil. Draw an outline around it, thickening it and giving it some flair.

2. Use a 1.2mm writer pen to outline the letter. Erase the pencil lines.

3. Use a .05mm writer pen to doodle inside the letter.

Suggested Tools:
- 1.2mm writer pen
- .05mm writer pen

Lettering WORKSHOP FOR Crafters

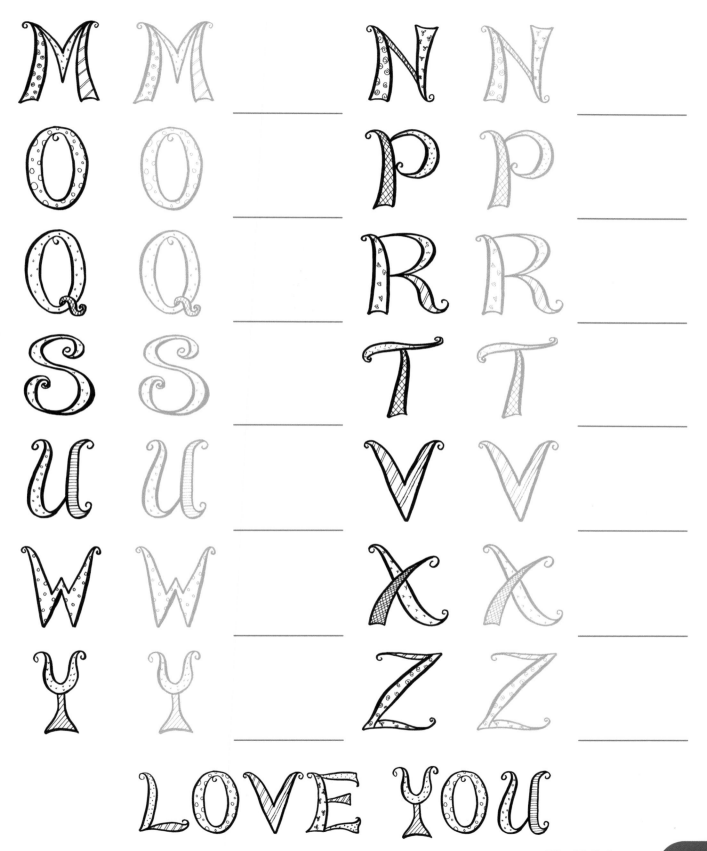

Stencil Letters

How to Do This Alphabet

1. Align an alphabet stencil and use a pencil to trace the outline of a letter.

2. Remove the stencil, go over the letter with pen, and erase the pencil lines.

3. Doodle inside or on the edges of your letters.

Suggested Tools:

- Any pen
- Alphabet stencil

Lettering WORKSHOP FOR *Crafters*

Calligraphic Letters

How to Do This Alphabet

1. Draw a basic letter in pencil.

2. Add embellishments to the tips of the letter.

3. Outline the letter using a calligraphy pen, making sure to hold the pen at a 45° angle. Erase all pencil lines when the ink is dry. Go over the top of the letter with a colored marker, following the lines precisely.

Suggested Tools:
- Calligraphy pen
- Colored marker

Lettering WORKSHOP FOR *Crafters*

M M N N

O O P P

Q Q R R

S S T T

U U V V

W W X X

Y Y Z Z

YOU'RE INVITED

Main Line Letters

How to Do This Alphabet

1. Draw a basic letter in pencil.

2. Hold the calligraphy pen tip flat against the paper and pull down.

3. When working the curves, pull the pen away from you, keeping the tip flat. Finish the letter with a .5mm writer pen.

Suggested Tools:
- Calligraphy pen
- .5mm writer pen

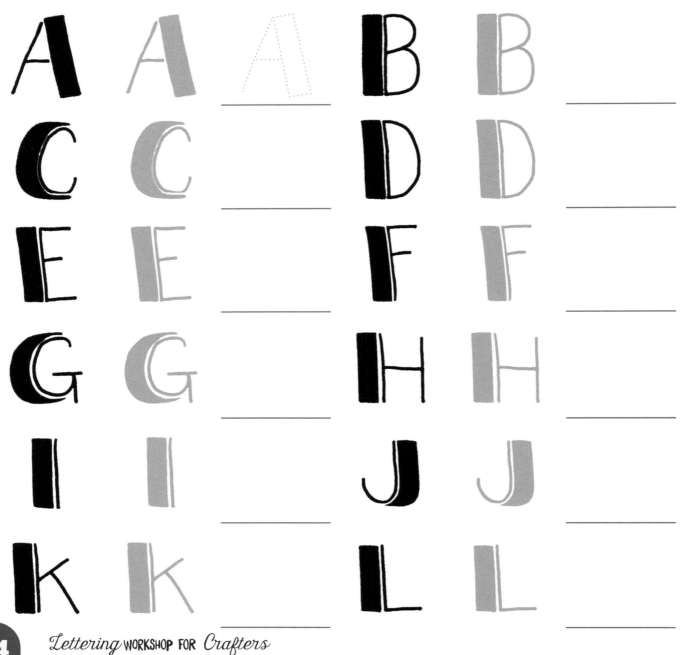

Lettering WORKSHOP FOR *Crafters*

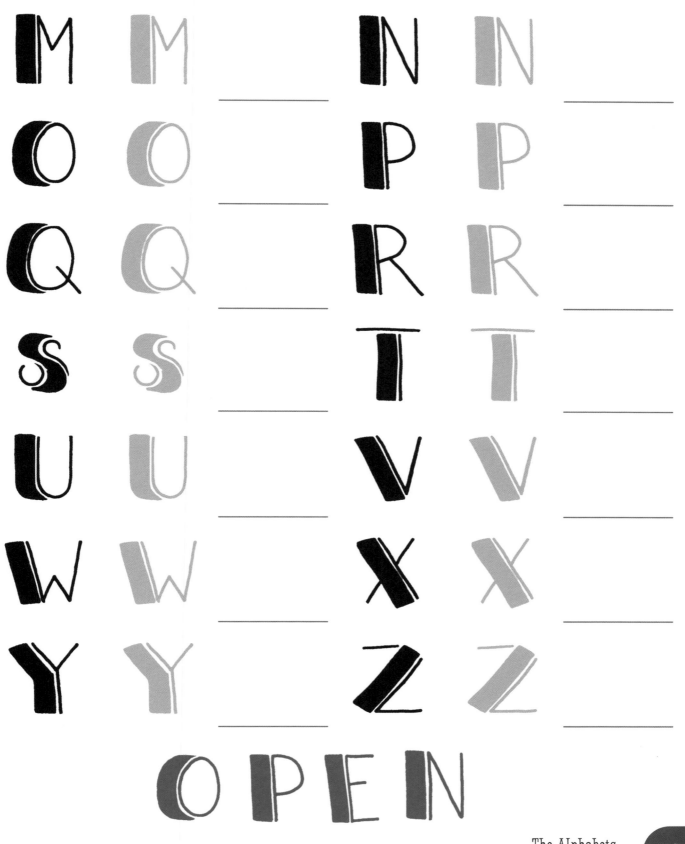

Gothic Letters

How to Do This Alphabet

1. Hold your pen at a 45° angle consistently as you draw the letter.

2. Move the pen from top to bottom, keeping the letters vertical.

3. Add serifs and embellishments last, keeping the pen at the same angle.

Suggested Tool:
- Calligraphy pen

Aa Aa Aa Bb Bb

Cc Cc Dd Dd

Ee Ee Ff Ff

Gg Gg Hh Hh

Ji Ji Jj Jj

Kk Kk Ll Ll

Mm Mm _____

Nn Nn _____

Oo Oo _____

Pp Pp _____

Qq Qq _____

Rr Rr _____

Ss Ss _____

Tt Tt _____

Uu Uu _____

Vv Vv _____

Ww Ww _____

Xx Xx _____

Yy Yy _____

Zz Zz _____

Old English

Double Script Letters

How to Do This Alphabet

1. Draw a basic letter in pencil.

2. Hold the pen tip flat against the paper and follow the pencil lines.

3. Be sure to press evenly against the paper to prevent skipping. Erase all pencil lines.

Suggested Tool:
- Scroll-tip pen

Lettering WORKSHOP FOR Crafters

m m n n

o o p p

q q r r

s s t t

u u v v

w w x x

y y z z

make your art

Fill-It-Up Letters

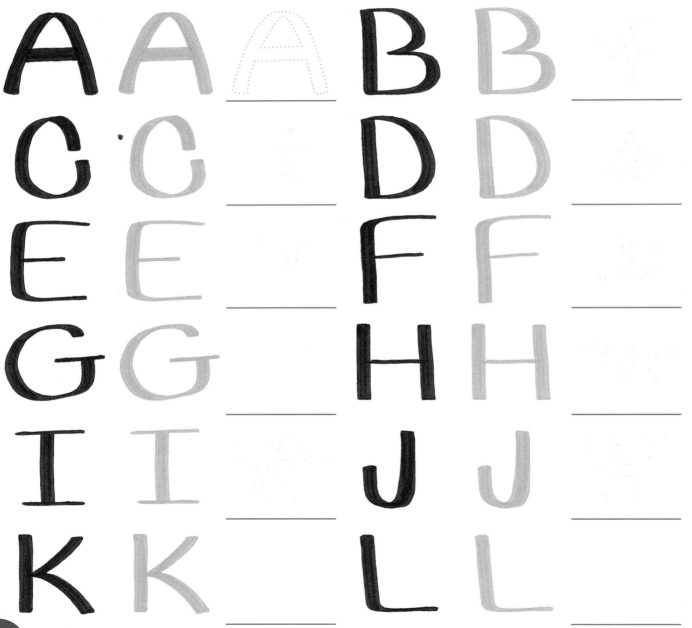

How to Do This Alphabet

1. Use a scroll-tip pen to draw your letter.
2. Use a brush-tip pen to close the ends and to fill in the letter.
3. Try two colors for more fun!

Suggested Tools:

- Scroll-tip pen
- Brush-tip pen

Lettering WORKSHOP FOR *Crafters*

M M _____ N N _____

O O _____ P P _____

Q Q _____ R R _____

S S _____ T T _____

U U _____ V V _____

W W _____ X X _____

Y Y _____ Z Z _____

ZOO TRIP

Twice-As-Nice Letters

How to Do This Alphabet

1. Keep the thin side of the scroll-tip pen to the left and draw a basic letter.

2. Use a brush-tip pen to add color.

3. Clean the tip by wiping it on paper before storing.

Suggested Tools:
- Scroll-tip pen
- Brush-tip pen

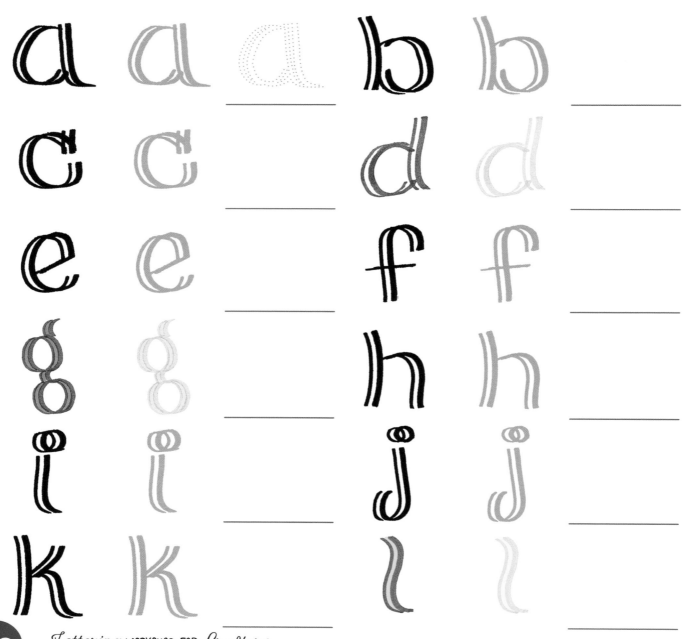

Lettering WORKSHOP FOR *Crafters*

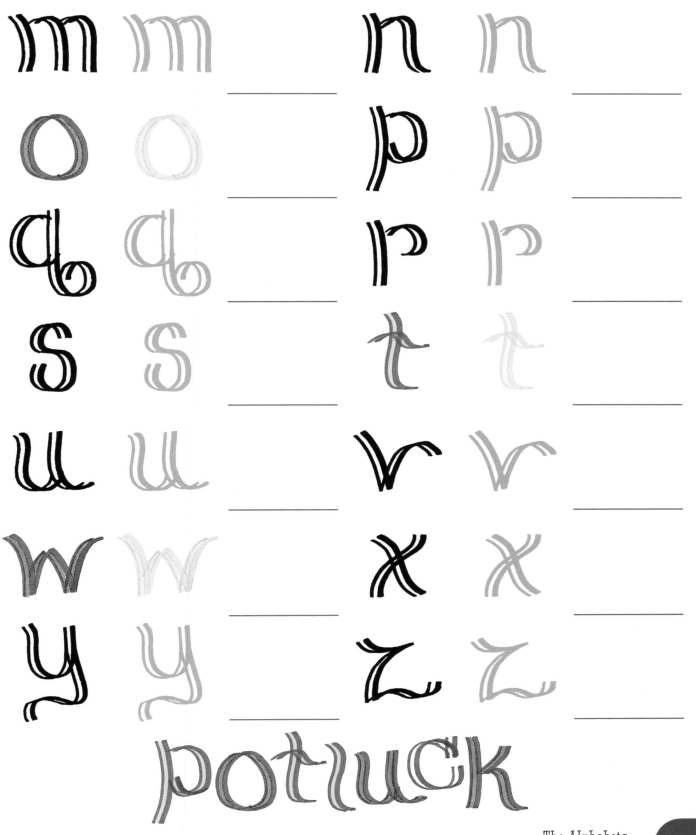

m m n n

o o p p

q q r r

s s t t

u u v v

w w x x

y y z z

potluck

Double-Time Letters

How to Do This Alphabet

1. Hold the scroll tip flat against the paper and pull down.
2. Use a ruler for straighter lines.
3. Slide the tip across for crossbars on the letters.

Suggested Tools:
- Scroll-tip pen
- Ruler

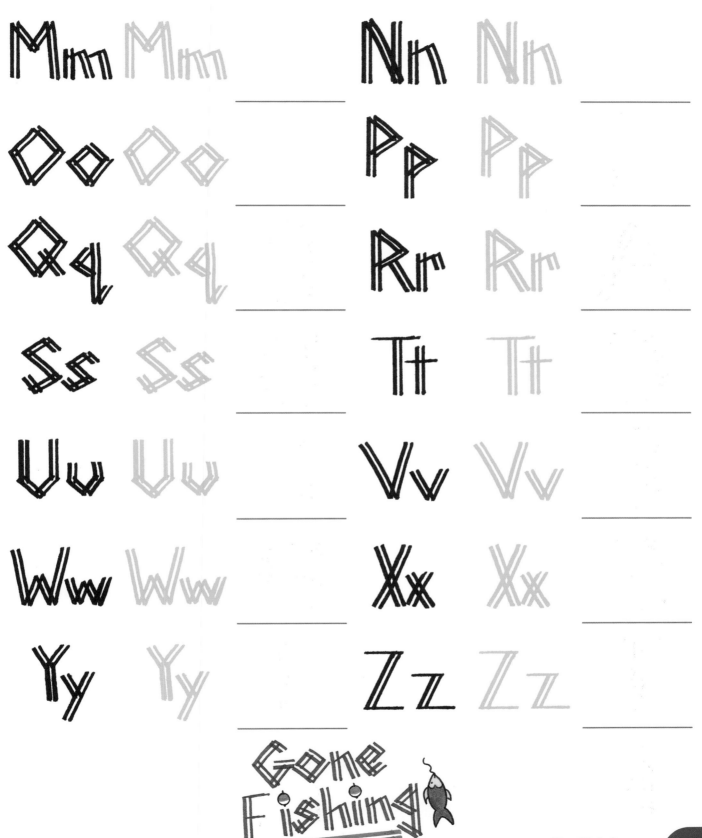

Mm Mm

Nn Nn

Oo Oo

Pp Pp

Qq Qq

Rr Rr

Ss Ss

Tt Tt

Uu Uu

Vv Vv

Ww Ww

Xx Xx

Yy Yy

Zz Zz

Gone Fishing

The Alphabets

Scroll—Tip Letters

How to Do This Alphabet

1. Draw a basic letter in pencil.
2. Use a ruler to draw baselines with a scroll-tip pen.
3. Finish with a fine-tip pen and erase all pencil lines.

Suggested tools:

- Scroll-tip pen
- Fine-tip pen
- Ruler

A A A B B

C C D D

E E F F

G G H H

I I J J

K K L L

Lettering WORKSHOP FOR *Crafters*

Easy-Does-It Letters

How to Do This Alphabet

1. Hold the brush-tip pen like a regular pen and let the letters flow smoothly.

2. Use medium pressure to draw the letters.

3. Let up on the pressure as you draw the curves.

Suggested Tool:
• Brush-tip pen

Aa Aa Aa Bb Bb

Cc Cc Dd Dd

Ee Ee Ff Ff

Gg Gg Hh Hh

Ii Ii Jj Jj

Kk Kk Ll Ll

Mm Mm

Nn Nn

Oo Oo

Pp Pp

Qq Qq

Rr Rr

Ss Ss

Tt Tt

Uu Uu

Vv Vv

Ww Ww

Xx Xx

Yy Yy

Zz Zz

Menu

Embellished Brush Letters

How to Do This Alphabet

1. Draw a basic letter in pencil.

2. Follow the lines with a brush-tip pen and add curves as serifs.

3. Optional: Add circles on the serifs for extra decoration, or outline the letter with a fine-tip pen.

Suggested Tools:

- Brush-tip pen
- Fine-tip pen (optional)

Lettering WORKSHOP FOR *Crafters*

M M _____ N N _____

O O _____ P P _____

Q Q _____ R R _____

S S _____ T T _____

U U _____ V V _____

W W _____ X X _____

Y Y _____ Z Z _____

PUPPY LOVE

Contemporary Brush Letters

\mathcal{A}
\mathcal{A}
\mathcal{A}

How to Do This Alphabet

1. Hold the brush-tip pen like a regular pen and let the letters flow smoothly.

2. For the thin lines, use light pressure. For the thicker lines, use firmer pressure.

3. Practice changing pressure and curving your letters smoothly.

Suggested Tool:

- Brush-tip pen

Aa *Aa* *Aa* *Bb* *Bb*

Cc *Cc* *Dd* *Dd*

Ee *Ee* *Ff* *Ff*

Gg *Gg* *Hh* *Hh*

Ii *Ii* *Jj* *Jj*

Kk *Kk* *Ll* *Ll*

Lettering WORKSHOP FOR Crafters

Mm Mm _____

Nn Nn _____

Oo Oo _____

Pp Pp _____

Qq Qq _____

Rr Rr _____

Ss Ss _____

Tt Tt _____

Uu Uu _____

Vv Vv _____

Ww Ww _____

Xx Xx _____

Yy Yy _____

Zz Zz _____

Merry Christmas

Brush-Script Letters

How to Do This Alphabet

1. Hold the brush-tip pen like a regular pen and let the letters flow smoothly.

2. For the thin lines, use light pressure. For the thicker lines, use firmer pressure.

3. Practice changing pressure and curving your letters smoothly.

Mm Mm Nn Nn

Oo Oo Pp Pp

Qq Qq Rr Rr

Ss Ss Tt Tt

Uu Uu Vv Vv

Ww Ww Xx Xx

Yy Yy Zz Zz

Believe

The Alphabets

Design Your Own Alphabet

Lettering WORKSHOP FOR Crafters

Design Your Own Alphabet

Lettering WORKSHOP FOR Crafters

Design Your Own Alphabet

Decorations

Making word art or adding decorative corners and borders to your crafting projects is an excellent way to really create something stunning. They're the perfect way to add color and patterns to your hand lettering. Look to the pages that follow for inspiration when crafting.

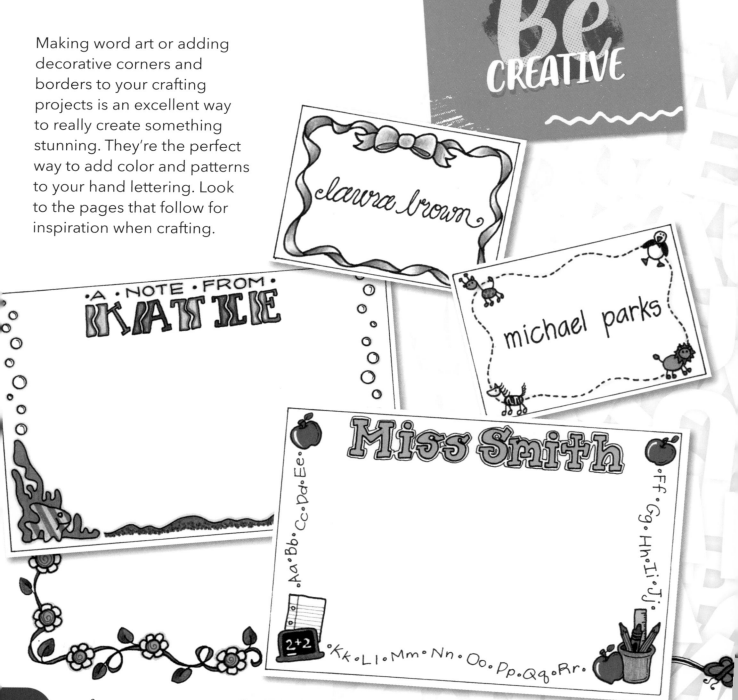

Be CREATIVE

laura brown

·A·NOTE·FROM· KATIE

michael parks

Miss Smith

·Aa·Bb·Cc·Dd·Ee·

2+2

·Kk·Ll·Mm·Nn·Oo·Pp·Qq·Rr·

·Ff·Gg·Hh·Ii·Jj·

Lettering WORKSHOP FOR *Crafters*

A WORK OF

ART.

BABY

this book belongs to MIKEY.

cake

OUR TRIP TO the ZOO

SWEET HEARTS

Word Art

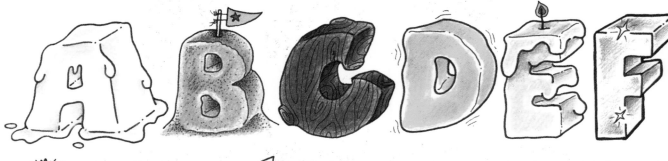
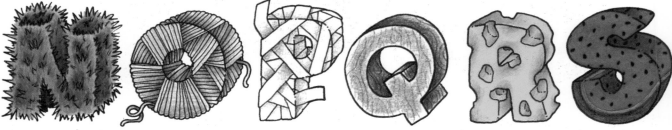

Lettering WORKSHOP FOR *Crafters*

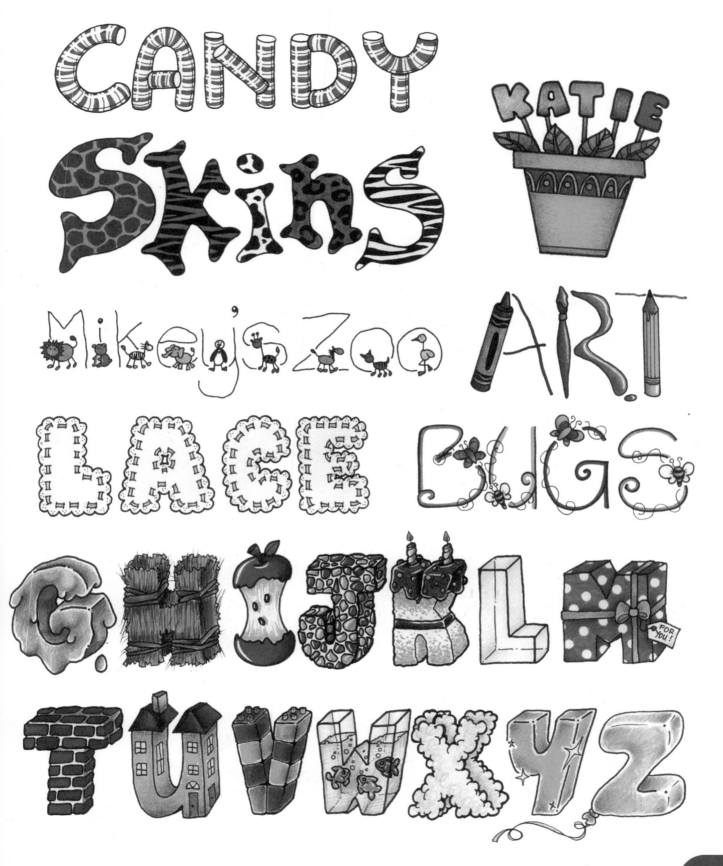

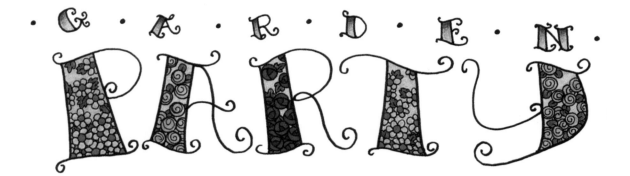

GARDEN PARTY

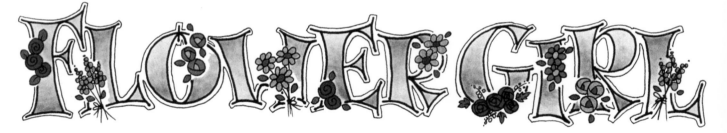

CARNIVAL

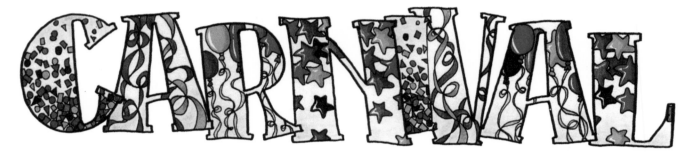

FLOWER GIRL

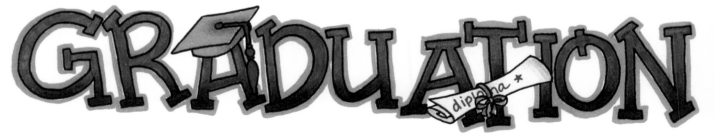

GRADUATION

diploma

Anniversary

Lettering WORKSHOP FOR *Crafters*

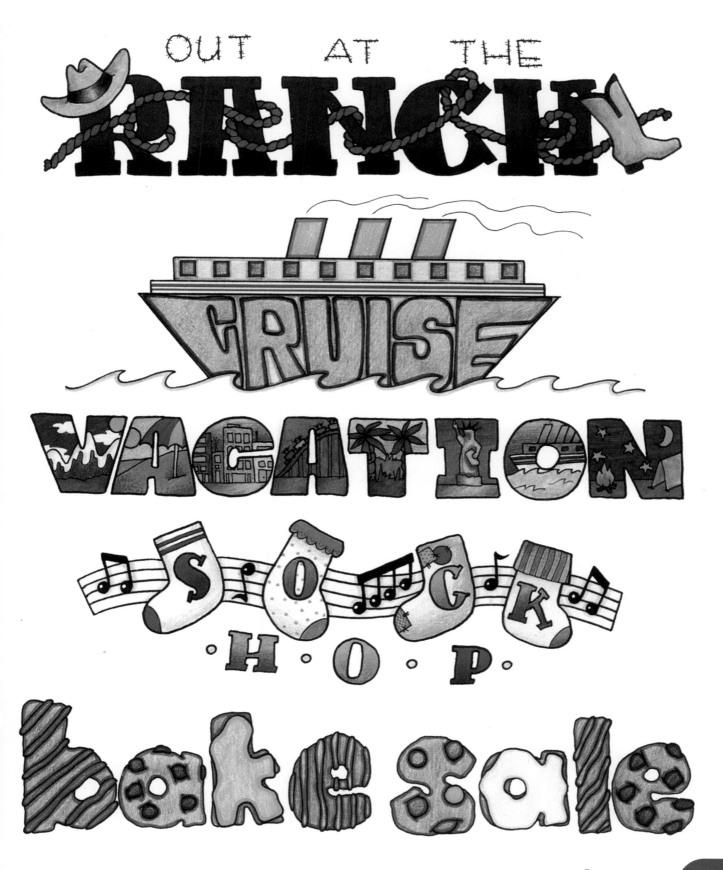

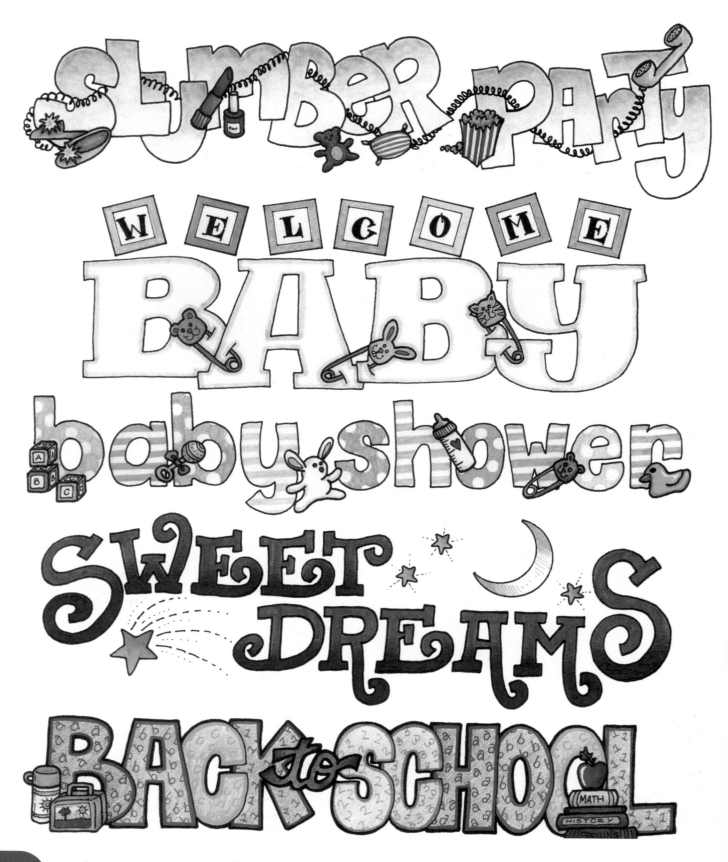

SLUMBER PARTY

WELCOME BABY

baby shower

SWEET DREAMS

BACK to SCHOOL

Lettering WORKSHOP FOR *Crafters*

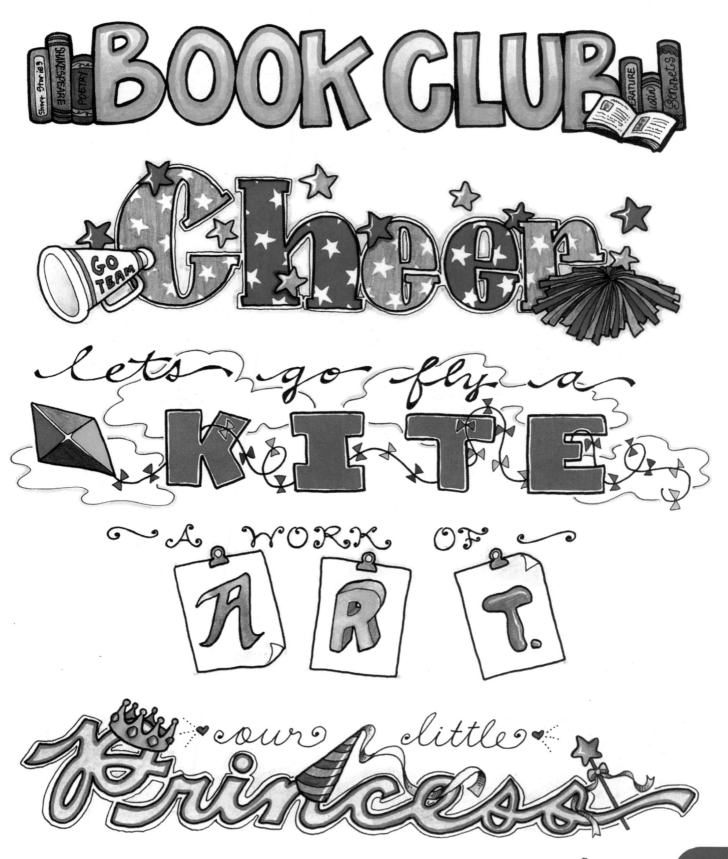

BOOK CLUB

Cheer

lets go fly a KITE

A WORK OF ART

our little Princess

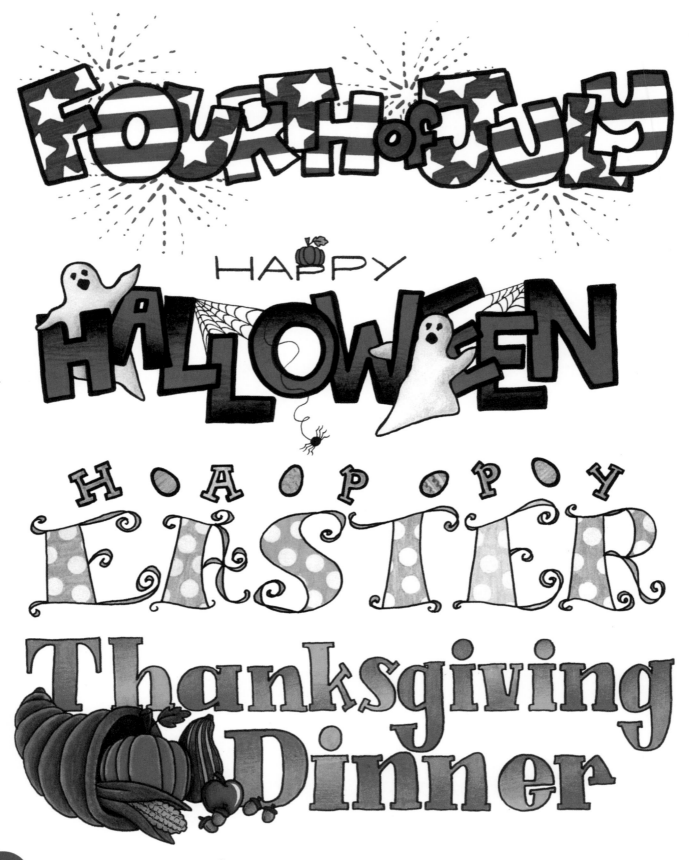

FOURTH of JULY

HAPPY HALLOWEEN

HAPPY EASTER

Thanksgiving Dinner

Lettering WORKSHOP FOR *Crafters*

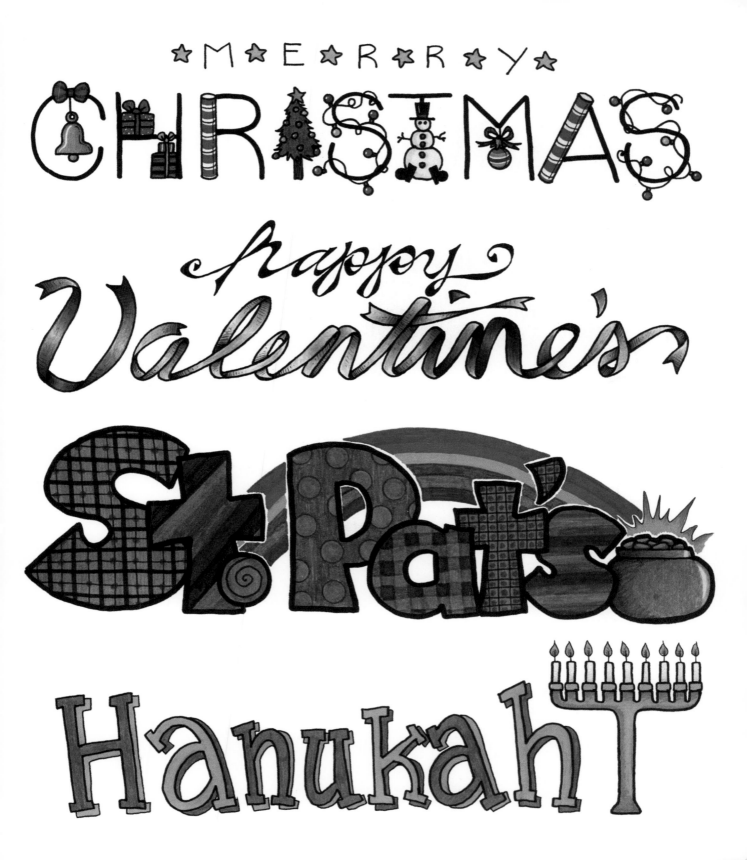

*M*E*R*R*Y*
CHRISTMAS

happy
Valentine's

St. Pat's

Hanukah

Corners & Centers

Lettering WORKSHOP FOR *Crafters*

Borders

Lettering WORKSHOP FOR *Crafters*

Lettering WORKSHOP FOR *Crafters*

Decorations

157

Envelopes

Personalizing your envelopes is the perfect way to give your letters and cards a little something extra special. Trace and cut out the template on the next page. Laminate it or paste it to a thick piece of poster board so you can use it again and again. Trace your master template onto pretty scrapbook paper and hand-letter the recipient's name and address. The envelope is a post office–approved size, so you'll be able to easily send them in the mail.

1. Trace the envelope template onto a piece of paper. Tip: Try double-sided scrapbook paper for a colorful interior.

2. Letter and design your envelope.

3. Cut out the envelope carefully with a craft knife or pair of scissors.

4. Referring to the dashed lines on the template, create the shape of the envelope by first folding the two side flaps in toward the center, then folding in the bottom flap. Double check the way you're folding so your favorite scrapbook pattern is on the outside of the envelope and the accent color is on the inside.

5. Tape the bottom three folded flaps of the envelope together, leaving the top flap free to open and close. If you plan to hand deliver your envelope to its recipient, feel free to only tape on the inside, where the tape will be hidden. If you want to mail your crafted envelope, reinforce it with extra tape on the outside seams of the flaps to ensure that the envelope doesn't come open in transit.

ENVELOPE TEMPLATE

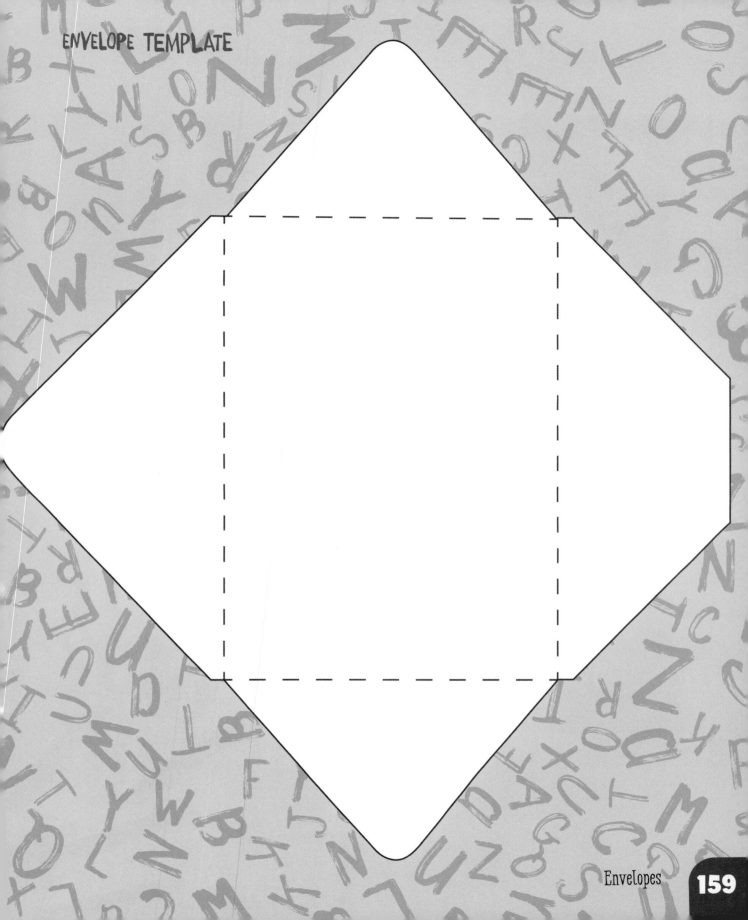

About the Contributors

Suzanne McNeill
Suzanne McNeill received the Lifetime Achievement Award from the Craft & Hobby Association and has been noted as one of the arts and craft industry's top trendsetters. Dedicated to hands-on creativity, she is constantly testing, experimenting, and inventing something new and fun. Suzanne is the author of more than 230 craft and hobby books, and her creative vision has placed her books at the top of the trends for over 25 years.

Cyndi Hansen
Cyndi Hansen has been crafting her whole life and has tried every craft imaginable. She has worked as a craft designer and as a florist. She loves designing album page ideas and projects that will add flair to memory books. Cyndi also enjoys using hand lettering to personalize projects and gifts to make them even more enjoyable to ̶ and friends.

Andrea Gibson
Andrea Gibson loves making things with her hands and sharing her creativity with others. The fun alphabets she created for this book were made to inspire creativity. She enjoys designing layouts, cards, and jewelry.

Tonya Bates
Tonya Bates spends her time creating crafts and fine arts. She enjoys papercrafting, painting, sculpting, ceramics, drawing, decorating, and playing the piano.

Kathleen Vandiver
Kathleen Vandiver was ̶ raised in Texas and is a ̶ of Texas A&M University ̶ Southwestern Medical S ̶ is currently an Assistant ̶ UT Southwestern in the ̶ department. Kathleen h ̶ loved to draw and pain ̶ spare time.